RED FLASH ON A BLACK FIELD

BLACK SQUARE EDITIONS

JOSEPH DONAHUE

RED FLASH ON
A BLACK FIELD

NEW YORK, NEW YORK · MMXIV

BSE BOOKS ARE DISTRIBUTED BY SPD:

Small Press Distribution
1341 Seventh Street
Berkeley, California 94710

1-800-869-7553
orders@spdbooks.org www.spdbooks.org

CONTRIBUTIONS TO BSE CAN BE MADE TO:

Off The Park Press
73 Fifth Avenue
New York, New York 10003

(please specify your donation is for Black Square Editions)

TO CONTACT THE PRESS, PLEASE WRITE:

Black Square Editions
1200 Broadway, Suite 3c
New York, New York 10001

An independent subsidiary of Off The Park Press

CONTENTS

for Evan and Nathaniel

Here's your ounce of whiskey for today.

– JAMES SCHUYLER

PARADISE POSTS

WHERE EVERY HOLLOW HOLDS A HALLOW

I sleep in a tree. At night,
the tree flies to a beach where
the pebbles are gems.
Thunderclap: the moon
in bits. An office,
a chair in front of a desk,
a hitch in the interview: your
advocate, it seems, is a Nazi.
Nervosina, in the well of a pillow,
who now whispers my name?
The sky's a dirty sponge.
The earth, a bucket.
A billing fiasco looms.

Meanwhile, on a red field
wet light gleams. (Was it so long
ago we drew the shades
at lunch, then ate
pound cake, fresh
from the freezer, and
Dad sipped vodka
as we sat in the dark,
playing comedy albums?)
An escapee lurks by a school.
Everywhere, choppers and cops.
But for kids, the lockdown
is a weird carnival on an
autumn night, so Egyptian.
A dry run for the Angel of Death.
The doorway of the forest is

brushed with blood. Help me.

My mouth's out of whack.
Lies leap out. A white mist
hides the lake. The air glows.
A red spine shoots through a leaf,
the flame of all that will fall.

I sleep in a barrel. At night,
the barrel flies to a mountain.
The cliffs are sapphire.
Where the Hesperus
went up in flames
the former landlord of
Charles Olson offers me
planks from his room.
The mesh of the fence blurs
the hog wallow by the reef.
The hills blow sideways.
Lakes hang in the sky.
Trees lean over the shade.
Herons, the color of water.
A ghost floats inside a rainbow.
Overhead can be seen a sun
toward which open
rare blossoms of thought.
(Crowded room, we spoke
as if in bed, marveling.)
While along back roads,
the new law ruins all.
I want to bury my head

in the hood of my car.
Then a college dean
collars me, crows to all
under the reunion tent:
Meet the one among you
renowned for classes missed
due to venereal misadventure!
I sleep in a gazebo. At night
the gazebo flies to a desert.
The spiders are feldspar.

Sky-wide camera flash.
Let our eyes open. Or else
the sun become an estate
that will not survive the
survivors, all light lost in
an Iliad of attorneys.
God loves Kansas.
Revivals roll west. We
could argue we are now air,
but the wind on our skin
says no. We could show,
in the 1840s, a silversmith
rebuilding the temple of Solomon
in secret as a cider mill on a hill.
We could be *lying helpless,*
scenes of glory passing
before my eyes. (Historians
call this the "fire zone.")
We could dream the earth is

a greasy aluminum pan,
the ocean, tied down
with garbage bags, green
and seething. Beach,
a gulag of mud, couples
in the mud, limbs streaked
with mud, children playing
with mud, bathers with towels
crossing the mud, down to
the plastic-covered sea.

While I was away, who lived?
While I flew deep, who defamed me?
While I soaked in the light of
the fire of Heaven, while I
opened the archive of what is,
who paid for these alterations?
Who signed this card, had my spasms?
While I felt what perfection was like,
while I walked with Tobias,
who changed the locks?
While the throne shone,
while ancestors kissed me,
what polar cold swept down?
While the undulation broke wild,
who reviewed my scandals?
While the whirlwind held me,
who broke my bones?
Who underbid me?

LULU MAKES A MOVIE

A docudrama, where Love
or Lulu or Lou Andreas Salome
films the chastening of her sex life:
It will be for the camera this time,
so it will have to be real sloppy,
and rougher than before.
Clearly, time is about to fold
in half, then turn inside out.
Must be Rosh Hashanah.
Adonai, remake the world.
The shofar's reverb finds Isaac
mountain climbing: What is that?
A sad ram with a shattered hoof?
Aleph, Bet, Gimel, Dalet, Hey...
Must be images of the future flare
as the fountain water touches
the mirror. Roil and gleam, purity
upon purity, glaze of liquid on
the glass in the glitter by the
supermarket boasting a new
aisle: Nazi cookware. Awed by
such elegance, who would not
pony up for a "putsch pot?"
A wife advises: *Honey,*
we already have a putsch pot!
It seems the masseuse must
press the hot oil deeper under
the edge of your skull, whispering:
Let the video helmet tweak your
fear cues. You're a hit man

in a lost Scorsese reel. Lit pool,
wild party, patio, a huge house
on a cliff over the moody
Pacific. Inside, Tony pinches
a fat, terrified face, says just as
you enter: Hey, Uncle Zabby,
this guy came to blow out
your brains, make nice red art
all over these white walls. But it
turns out today is Ma's birthday,
you lucky sack of shit, so we'll
be gettin' in touch with you later.
Aleph, Bet, Gimel, Dalet, Hey…
The new antidepressants are
purposely erratic, to give us
back gulps of original zest.
Once again, alone, you can be
terrified by squirrels on the roof –
oh god, the house is on fire…
Woven firmly by the angel of
birth, the basket of consciousness
gathers what our offering will be.
As every child knows: *When*
I'm old and dead that cartoon
won't scare me anymore,
the one about the dog
abandoned in the Arctic
who lives on a chunk of ice
drifting over the drowned world.

IMMORTAL ELLIPSE

A class science project
over at the grammar school
high on a hill in a whirlwind of white.
(The waking world's a tornado
of snow, a throne in the air.)
A sharp-nosed student notes:
Fruit flies don't even want it now.
That leaky death's head,
that jack-o'-lantern.
And the teacher, to them all –
Write down what's happening.
See if the rot has a plan.

•

The soundtrack still
murmuring, and the TV off –
our tablet, our emerald plasma.
All images die in a Magnificat of
rotten smoke. Turn sweet,
floating roots. From
residue, a terra lucida,
from ashes, a chalky pool
with goat bones in a clean boil,
what tradition calls "the Bath of the King,"
what Laura Palmer (so full of secrets)
breathes in Agent Cooper's ear.
While in India, the devout
dip in rivers at dawn, robes

swirling, sun-colored, at their feet.
May gold wake to living glitter.
May our filth perfect us,
though a dream shows me
still unrefined, petty, pleased
in denying a queen who's
ill for want of what
I hold back, healing pages of...
But first, in the painting
by Elihu Vedder, has the fallen
alchemist drunk the elixir?
What glint graces a lab so dark?

•

The soundtrack still
murmuring, and the TV off –
the *Twin Peaks* festival rolls
on all night. And the Log Lady –
The fire I speak of is not a kind fire.
And asleep at last, I'm riding
a disintegrating meteor,
pulsing planets overhead,
a distraction from the singing bits
theorists say shoot through us all hours.
Fish gleam in green streaks.
Deep under the sea now, I pick
from the glowing sand a stone
the size of a child's skull.

In my hand, I feel the
quick of the force
that formed it, like the
whirling of thought within
a mind about to be.

•

But am I that Samson,
cranking his blind wheel?
Until you saw him like that,
you could never love me,
leers the chief priest of
a Technicolor Gaza –
But once, my Hedy Lamarr,
passion pulled us to the side
of the road. Night wove a thin
silver chain across your belly.
The links were my kisses,
lit by roving cars. Here are
your hours. White fire falling,
incandescent, knee deep,
devouring the valley while
on the world map at the school –
a nativity star gleams for each pupil.
Birth Happens! the stencils ring out
as if announcing newly arrived
souls in an alternate afterlife
where one, your namesake,

kicks off morbidity, and looks around.
(Gold dome chant. Sweet smoke,
holy rote. Did you mishear?
Were you hailed as one
crawling toward heaven?)

Here are your days, flakes
blowing by as the movie starts –
The Island of the Burning Doomed.
Last night, a woman with
auburn hair lounged on a ledge
in a reddish-yellow velour bodysuit.
At first, she appeared to be on fire.
Or naked, a fantastic animal
in a symbolist painting.
Then she spoke: *I am*
a concert pianist,
devoted to the music
of madness and death.
And on my lips as I woke:
Would that be, uh, Scriabin?

A rowboat in the reeds
or a wineglass at the Café Inferno

or a train rips through, another stops.
The cops scan the surge. Go frantic.
Do nothing. *This all should be*
commercially zoned. Damn
the Hessians who camped here.
Also, angry Hera, throw down
a whirlwind of snakes from the sky,
though x-rays show a mist over the inlet,
willows over water. When my head
turns at last into the head of
a donkey, leave me at least the
last constellations, the Vigorous Leech
or maybe the Ocelot Hauling a Cart of Pigs.
First figures are returning as burrs in
the mire of exploded thought –
like a syringe, red pouch,
Velcro seal, filched adrenaline,
or the powder-blue walls of a wild motel.
Impromptu memorial, mid-bridge.
Notes to the dead sop the dew.
High over the rocks, over white
rips in the stream cutting through
a city where citizens feign they
are not ghouls, dust fills our mouths:
When it all got desperate, you were
indifferent. So what's this sudden burst…
And that, from the concierge desk
of an understaffed spa.

•

Now a girl in red, floating close:
We're part of Viacom, we own Showtime.
It's all a big chart on the office wall.
The empty bench at the train station,
the man preaching to the air:
Zacharias didn't believe
what Elizabeth told him
God would do. Got struck dumb.
Was that an art critic or a theologian
who said redemption would be
biowaste and tires in gray slop?
A beach, then blue to the horizon.
Earth, the crust of a buried star.
Warmth shimmered along their limbs.
The grains are pearls. The pearls are salt.

•

black sun

In the hills, trees drip with ice.
In the valley, bathers loll in stone pools.
In the hills, X waits for her husband
(he's on business in Brazil).
In the valley, you toss,
dreaming of X.
In the hills, moods could be
a truth, not just the sweep of bees

toward the flowering lilac along the lake.
In the valley, lightning all afternoon.
In the hills, clouds fill with light.
In the valley, this leaf-heap,
mud-wallow world, come
first green, will be
a boulevard in Paris:
the skyline's flare a vest
you wear tottering home
from a champagne and opium blowout –
Alive, awake, new every morning,
sang the esteemed murderer,
our suicide of means,
Harry Crosby,
occult crosses tattooed
on the flip side of his feet –
The arrow of my soul pointing to Ra.

•

Day, a dry creek bed:
concrete-colored shale and
vanished babble beside a path.
A banquet will be, all will be called.
But for us, dreams are the one creed.
I fly toward death. The plane drops
down to an empty field at night.
A diorama of black trees
a child draws inside a shoe box.

Orange moonlight. A road rolls out.
An eerie castle looms. Inside are
halls with yellow finches
in a waterfall of foliage, deep
in a century of peril and high
adventure, harp strings,
clarinets in a desert wind.
The torrent smooths to a pool –
a triptych of mirrors where
tailors genuflect before a beautiful
queen, touch the flowing hem, and quit.
In the hours before the ball, show me,
secret love, your folds of white fire.
Who can add the fractions of
what is? Denominators run riot.
They are the flakes in a flurry
hiding a building where research
presses on. Stories, frightful, funny,
marvelous, or just informative,
are read aloud to children
who scurry to find patterns
in an unraveling ball of thread.
A huge tree cracks, white wood
glows, lashed with ice, that inner grain
that has never felt, until now, the
whirl of water and air in a wind
pulling all from the earth.

•

Such ecstasies are purely
molecular, Thoreau noted
one winter, traveling deep into
the mountains of Sweden. An immortal
bird is making a nest in the dark of
a dream, gold wires pulled from a rip
in a live cable, a glitter within
which nothing yet lives.
My dexterity with viola
and bow led Chairman Mao
to further my musical studies
in a fabulous slaughterhouse
miles from anywhere. What
new notes drenched me, in that
trench of blood, arising from the en-
trails of the enraged animals
I so haphazardly gored!

RAIN FOREST

But first, the cryptology
class: a pile of broken crosses
by a train platform, a forlorn actress
begs for a real kiss. You have quit
your home, that hermit cell,
that deluxe camper in a ditch,
that dream in the flames,
a skeleton in the seat where
you still burn, an evangelical
cokehead, each blackout a rebirth.
The seizures at the wheel are
petals on a dead tree, a ticket
to a zoo, a divinity school
flashback: ringed by the
redeemed, gripped for Spirit,
other mysteries intruded:
how a girl, sprung from
a hanging judge, hip deep
in the prophecy tub, ends up
writing new slogans for
thermal flow skins. *Feel
the Heat!* And: *My mind is
light, lost in new loves.*
In the drift of the Argo,
and the beauty of Medea,
who torched, quite recently,
a club, a playground, and a bed,
as incentive to her boyfriend
and all his motorcycle gang.
Once the film is shot, sounds

are plucked from an archive:
each drip, shatter, flicker, sigh
at turquoise stars, over the trains,
as whiskey snaps the ice, then
further clicks, whirs, scrapes,
whispers, and the rippling
of fire behind a door. But if
one listens with a new ear,
the one Christ gave back to the guard,
(the one in the grass in *Blue Velvet*)
the bubble flies free of the boiling.
The scuff of the sole on the wet
street repudiates the shoe.
(And the lurid light across
lovers in a hotel bed is not
from the pop of a bomb.)
So that, dreaming, near glacial
peaks, a perfect party, you
feel happy but look sad.
A guest, a ghost, your mother,
pulls you aside. *I guess you*
do get it: I'm not really alive.
Morning pulls the dew back.
The tent shines. The last traces
of who you were dissolve
like hawk shadow
over an aqua-blue bay
pocked with the pink of the sky.
I've had numerous nightmares here,
the ranger confides, before

her campground slide show:

"The Dynamics of Death."
Radios tucked in their guts
can now track where the salmon
will be dragged, devoured, expelled,
and scattered. Don't forget the
fireworks later! I really love
those "Crazy Groundhogs."
They spin, sizzle, and explode.
Near a waterfall, dreaming:
another ghost, a monk in a mall,
Philip Whalen, on an escalator.
(Impermanence is incredible.)
Finally, you awake at a wedding.
A priest from Bali pours out
a pitcher of silver coins.
The kneeling bride catches
what she can of what
falls, glittering, before her eyes.

TELEPHONE, MISSISSIPPI

after a painting by Randy Hayes

The shed is a vault of secrets. No window, no door. Only
a Freemason or a thief could get inside. In this late or early
light, the shed is an ad hoc, low-fee, low-maintenance tomb.
Access is through the bus: the door is black. It hangs beside
the white cube of the shed.

•

On the window, paint-streaked, a memorial message shines.
This is where an inspection sticker should be. (Is there a
graveyard, a blossoming bone orchard, behind the lot, hidden
by the empty bus?) The square says: Manuel Terry, 1915–1988.
From numbers rises a world, the world as it was.

•

Despite the paint, this is clear: the photos are largely of
structures, most of them vacant. Is the whole of Mississippi
on a holiday? No. A man walks toward a shop door. The door
says: CLOSED. Does the man doubt the sign? Can he see in?
Does he have the key? Is the shop in fact open? Will he
disappear into it, into the Creative Style Shop?

•

Not everyone is dead. Another stands, his back to us. On
a dirt street, a black child, a patch of shade behind her. And
through the window space and interior of the featured car,
behind some grass, behind the front half of a pickup, staring
at us, a man in sunglasses.

•

Slowly we awaken to the coal cars on a train track, the fences,
boarded storefronts, the dirt road with cars up ahead pulled
over, the flooded area with huge trees, the brush rising from
the water, the airplane banking away, the Coca-Cola signs, and
the weather-beaten, partially erased "Harris' Hot Tamales."

•

The car reminds me of a car covered with shaving cream and
streamers, a car from before I was born, a car in a picture in
a wedding album, a picture taken the day my parents drove
south to start their life together. The car was there again,
behind that infant held in my mother's arms, in pictures of
my christening. When they later bought a new car, they gave
this car to my grandmother, up north. When I was six, on my
grand northern tour, she and I drove around New England in
it. We went to Lake George. I met cousins I had never heard of,
would never see again, but who welcomed me among them,
as if I were a prince who has been placed under a spell.

•

At the Trout Pavilion Hotel, the dining room required a suit jacket. Luckily, in anticipation of such formality, my mother had bought me one, dark blue, with white squares. After dinner, I sang a song for the adults on the porch.

•

Later, we moved back north. My grandmother kept to her apartment down the street, but every morning, as the paper-boy for her building, I saw that blue Plymouth in her parking spot. I saw it again on my walk home from school. It was there in twilight, on Fridays, when I collected the weekly fee for the paper.

•

Every lonely widow in the city, it seemed, wound up on the edge of the less respectable neighborhoods, and got their news from me. I collected, as well, endless stories, often getting home past dark. My grandmother would give me cocoa, and tell me about her father. He had been a minstrel. He toured the West. He played the French horn. Once, in a prison show, he juggled for Frank James.

•

In "Now the Dead Prey Upon Us," Olson warns of the five
hindrances to our escape from the cycle of reincarnation.
He learns how hard it is not to be caught in the nets of
being. A dream image, odd and intimate, is at the center of
the summoning of chthonic forces and the contemporary
restatement of a spiritual dilemma spelled out by the pre-
Socratics. No chariot and horse needed, as in Plato, for the
soul, just a beat-up old car. When the living room, with the
movie camera running and the ghosts gathering, becomes
a repair garage with a car lifted up, its tires "masses of
rubber and thread variously clinging together," the poet
asks a spirit about hell.

•

A photo is set like a gem within the rear hubcap of the car
in the painting, a photo of the car itself, seen as it might still
be had it never caught the artist's eye. In the untouched
scene — where now is only the dark, sun-tipped leaves, the
white wall, slats of wood — is a pickup truck. A second bus
is there, a whole other reality, the one we know, but now
so distant, floating just beyond the first.

•

Finally, the eye finds the true subject, the telephone, encased
in a metal shell, with a sign with a bell and the word *telephone*.

Four poles rise partway from the ground. These mark where
a phone booth might once have been, or where a booth was
chosen to be, by whoever in Mississippi picks where phone
booths go. Then clearly, someone came, looked around, and
knew there was no need. There could never be any privacy
issues arising for any calls into or out of so quiet a place.

•

Untouched, purified by paint, the phone glows, as does
the trim cement slab from which it rises. There is a gleam
where a coin slot and dialing instructions might be expected,
perhaps a number for the phone itself, perhaps a name, a
"fuck you" scratched on the surface. But there is no dial, no
number pad, no place for change, no "fuck you." The sign
that said *telephone* is now a greenish-blue transparent
rectangle edged with white strokes. (I imagine the letters
glowing regardless through the night.)

•

What's yet to be said? That the receiver shimmers? That
it has an aura of yellow paint sharper than that spread by the
sunlight falling across the front fender of the car and the top
third of the white wall behind the car? That the door of the
bus is black bordered, with a burial ground beyond it?

•

36 That the phone box resting in light is an emblem of severed attentiveness, of impossible waiting in a lost place? Looking at it, we are exhausted, we are cast off, the heft of our bones oppresses us. We feel like members of a suicidal cult, about to hook our souls to a passing meteor. Our bodies, after all, are simply "vehicles." It's time to abandon them.

.

It's dawn. It's dusk. Who'd know you're here, looking at a car, a shed, a bus, a phone, a wall, a plant, a pole, a world beyond, behind these things? The phone seems about to ring. Who is the one from whom you wait to hear, who knows what the words are, words for you, and only, in all the world, for you, the words awaited, here, from who, from the one, from the one close enough to say them? You only have to wait. You don't have to answer, should the phone ring. But you have to wait, patiently, into the day, into the night, many days, many nights.

COPTIC OPTIC

Let all be a baptism of
fire or mayhem in full swing,
the actress – now nun – lets slip
to news crews at the convent
by the headwaters of the ...
O first to kiss Elvis on screen!
White noise sweeps away dead
words on a Styrofoam meteor
with a tinfoil tail shooting
plumes of dust and gas
through blue pipe stems.
(There will be a ribbon cutting
on Friday, though the scandal
of dreaming burns in our bones.)
Let all strike like sunlight
after laser eye surgery, when
one can almost see hermit crabs
and lantern fish drifting over
the ocean floor. Let all be fresh
in the first gust of snow where
schoolboys are smoking dope
on a chairlift. You remember
going up that mountain
but down's only a flash of white
lost in a surge of migratory birds,
lost forever, along with the panic
attack that proved so rueful,
in the relic room, when all
the butterflies went wild.
These bursts of daylight are

not drops from the pierced side
of the air, but cardinals un-
folding over the road.
They're the first flowering
of the pear trees, not simply
vultures in bare branches,
watching the sun fall, though
winter has cleared away
a generation of men, many of
whose movies we worshipped
in the years after the war.
Coptic wormhole, Coptic
ash, gash, slash, absence
in a scripture that would say
chaos is only a shadow outside
the limitless brilliance: "And
radiance poured from the
eighth heaven." And when
"the prime parent," (whom we
take to be Morton Feldman)
"saw the beautiful pulse of
light he was amazed and
ashamed, hovering,
in the rain-soaked glow,
the distant trees threaded
with silver, his thought little
more than a twist of wind,
a swirl of turquoise, a hand-
made noose, blue and green,
given long ago to guests at

the wedding of the elements."
God said to Moses: Go up
on the mountain and die,
unless you can guess what
I've got in this bag!
A fragrant swamp where
birds are agitated by the dawn?
Unless, God went on,
you can say what of what
has come to you should
pass now from your hands?
The skylight swings wide,
tips the roar of the ocean
right into the room. *But*
dissolve us not in our
dissembling. This mud
is my blood, says the
transgendered prodigal.

PARADISE POSTS

I

The hotel windows do not open. Snow is falling. I have been
engaged for two days, but my fiancée is not here. As a child,
I dreaded those outings to the ocean in the minivan when
everybody would be singing. Recently, I got a bad flu, and felt
cut loose from my body. I feel fine now. I feel I'm dreaming or
hallucinating.

II

I have long pink hair, blue eyes. In winter, I shiver in my floral
prints. Once, a boyfriend cornered me in the kitchen, pilot
light out, and a match in his hand. Recently, I met Sophie, a
decorator, in a black suit, with short green hair. We got close,
chatting about "satori" and "emptiness," "enlightenment"
and "compassion." We kissed. Yesterday she disappeared.
An unknown girl called.

III

A webcam with motion detection software scans my sleep.
I worry who will steal my success. The first night, a man
hangs himself from my chandelier. Second night, a little girl
points to a slide show on the ceiling. She says: This is what
John Lennon knew. This is why he was shot. The third night,
my brain bypasses my ear. I hear "Abide with Me." I don't
want to go away on a rocket ship. I want to stay here, and
watch the flamingos.

IV

She was nice. We dated. She started lying. We got married.
A year ago, we had twins. I have never seen them, but I see
her, on TV, drowning a little girl in Elysian Parks Lake. The
next afternoon, I pull up at a full-service gas station, but no
one comes out. My wife has a religion different from mine.
She is trying to save me.

V

He is who he is, as long as I am who I am. After sex, I feel
distant. I talk more and more. I spray paint my room with
anarchist cries. Later, opening manuals, I find a mesa, then
a house with murals on every wall, done by my mother in her
childhood in Majorca. Paint smears on a wicker footstool. The
filth shines. I'm a janitor. Once, this was my "ideal job," now
it's just fatigue and strange dreams. Nurses wrap me in wet
sheets. Back home, a new bartender takes over. I used to
heal others with a touch. Now I'm just "Little Miss Psycho."

VI

They will say about me: Katie was a cashier with no attention
span. No one will ever know my sister slipped me some LSD,
and that was how, finally, I fell in love with a man. In the
semi-dark, I wonder, can I sleep without destroying myself?
Tomorrow my husband leaves for boot camp. The girls will
stay with their "biological" mother. I am finally outthinking
my own brain chemistry, remembering the smallest parts
of the night I left the ballroom.

VII

My shrink gave no reason for my racist comment. Now
they have me in a bind. They made me sign a "letter of
understanding." My boss will only speak to me if I buy her
drinks. They try to get certain answers out of me. I tell them:
My dreams happen while I'm awake. Over the months, the
"yeah, right" of each quietly turns to "how do you know?"
I tell them: I am clairvoyant. My visitors come from the sun.

VIII

Before I was born, my mother killed me, but I burst forth
anyway, with a gleeful mind, full of virgin wonders. I will never
be a calendar with no vacation days. Once, I stuck a sewing
needle into my chest, to pierce my heart the way God, with
a thorn, pierced Paul. I will never forget who sheltered me
then, with love in abundance, and the promise of a beyond.

IX

Will my tongue burn if I say this? My brother was a limp doll.
I stroked his round cheek. I alone could quiet him. Amid loud
voices and music, I held his hand. I calmed him, a living ghost,
his eyes dulling as the last spark left them. Men fill the house,
and their pretty words. They tell my mother: When Tammuz
died, Inanna was so sad she trailed down to the house of
darkness, where dust lies on door and bolt.

X

I lie alone at night. I slip into my head. I whirl with starlight.
I'm away for hours. A snap, and I'm back, lying on my bed
again. My hands grow numb. Our insignificance takes my
breath away.

XI

I scrape paint off the fence. Thought engulfs me. I make an
incision. I cut "I am" into my pure, white, untouched school-
girl thigh. Moments later, looking down from the upsurge of
my mood, I see "Not Here," written in lacy letters. Blood
down my leg is warm against the cold of my skin. November.
I cut to stay warm. The cold is the cold of my soul. Blood is
the only warm that has ever touched me.

XII

My energy seemed hot and bright. Heaven had come to earth,
but my rapid speech and my enlightenment scared my wife.
Hiking in the hills, I was afraid I might disappear. I entertained
a "body of Christ wavelength." Then I saw that God has his
God, and he has his God. Then I saw the Ultimate God, so
lonely, in a chair in a hall of mirrors, with the faces of the
lesser gods in the mirrors all around him.

XIII

I had just been cut loose from music school. I let the guards think I was dangerous: in the lobby, head cocked, a distracted look. One said, "What are you still doing here?" I said, "writing."

XIV

3 a.m. in the garden, Buddhism hit me. I was lost in the pebbles around some plants, pushed out of place by the rain. We too will be shifted. A few years later, in the Grand Canyon, under the yellow-leaved cotton trees, the door of the Sistine Chapel swung wide. In the corner of Creation, a horned serpent squeezed a naked man. I told the Pope: Life is a series of binary events. On-and-off make a wave, which I have recently photographed.

XV

My soul is wind, vapor, a shadow, an image, a sketch, a mirror image in water, a phantom, an outline, a reflection, an echo, a will-o'-the-wisp, a shining cedar rooted in a spacious place where ancestors pull apart my bones, and eat my flesh, raw.

XVI

I'm all edges. I need a beating. I have fireballs under my
eyelids. I thought, just now, I hit the snooze button, but I'm
up, my running shoes on, dripping sweat, and ravenously
eating meat. I train break-neck, before dawn, at 8,000 feet.
I am, quite simply, a brutal opponent. But it helps to be on
the verge of menstruation.

XVII

All my "journeys" are mathematically sound. They take me
to the outward part of my personality, the part I share with
you. Yet my problem proves to be my thinking style. On my
wedding night I saw a girl I kissed once, 35 years ago. I told
my bride, right there. She cried. Yes, we have moved on, but
dishonest thoughts fill my chatterbox mind. I am a boiling
kettle with a broken whistle. My coherence shocks me. Still,
I write for myself, not for some marketing team.

XVIII

An astrologer who betrayed my trust, whom I then betrayed,
cursed me. She called on the planet that rules wounding.
She left me a shot knee and a crashed computer. When the
Venerable Somebody or Other fanned her fingers in my face
like a windshield wiper, my pain became a flow of quick and
vibrant images. When I touch my wife, I heal her mental scars.
Those who fall from my favor do so from an inability to get

real. Most of my fights are horseplay. I was rinsing out
shampoo, and a guy poured soap on my head. The thrashing
got wild. We were just two coal miners, bloodying up the nice
white tiles. We believed, then, the beautiful days of our mania
might become our every day, and we would all "enter heaven."

XIX

We moved town to town, just to see what was there. I rubbed
my hands together, a lot. My family called me "cricket." In
school I was "the walking power plant." I could electrify all
Europe, they said. I stared at my wrist and saw through every
layer of skin. Frequently, I fainted. Then I would twitch, jiggle
my legs, clap my hands, and sing. These days, people laugh.
"Speed freak." These days, I hang out with Wendy, at the
military base. Every soldier knows me. I'm an open book, they
say. I'm a book by Dr. Seuss, they say. The words are simple,
but make no sense.

XX

A man buys the house next to mine. He builds a large ware-
house. I get no sunlight. Trucks deliver at all hours. I get no
rest. In the dark night of such a bunker, even Hitler's spirit
would be broken.

XXI

Q: How does life start? A: Dragged into light and noise,
dropped with a cry. And so came Leon, my brother, lost,
made from the same parents as me. He nestled under the
same troubled heart. When he died, he went to the dream
he had always lived in more fully ever than this, as we see
it, this real world.

XXII

I looked around, went to sleep, and awoke back on earth. I felt
healthy again. I saw my mother had brought me outside and
covered my corpse with a bark mat.

XXIII

An ancient text called "The Lament of the Flutes" tells why
winter exists. Grief moved Ea, god of water and wisdom, to
send a heavenly messenger to the underworld to rescue the
goddess whose absence destroys life on earth. Reluctantly,
the King of Death let the messenger sprinkle Inanna, and
Tammuz, with the water of life. They flew back to the light
for six months. Imagine their delight. But, really, this is only
so Tammuz can die again, go into shadows again, so Inanna,
mad with grief, can chase him again, so her lament can move
Ea again, so the shine of life can scatter from the hand again
and the miracle of resurrection recur.

XXIV

My mother brought water from Lourdes. As we are Jewish, this was odd, but she took me for possessed. She poured each tiny bottle – there were hundreds – into a punch bowl. When I walked in that night, she threw the holiness in my face. People are still telling me what I did from that moment on. I remember nothing. I live the consequences, without knowing the details.

XXV

Many people can carry on successful, methodical lives, without enthusiasm. Their rejoicing simply dies. You are aging. You notice some things are not as neat and exciting as they once were, a snow cone, say, or the circus.

XXVI

For many blocks my teacher, a man with five decades of religious life under his belt, said nothing. Then, with one blinding gesture, he slammed the nattering novice to the ground, beat him black and blue. Screams filled the street. My teacher kept kicking the face, the swollen, bleeding face. Later, my teacher explained: A spirit need not be "good," but it must embody a certain enthusiasm.

XXVII

A fire-hose stream of Joan of Arc information hit me. The
next morning, a rat lay dead in our alley. The future shapes
the world, just like when, before you really bleed, you get a
kick of testosterone. My mother let me go places with friends.
She'd hunt me down and punish me, right in front of them.
A new love should be tender and caring. Shall I turn off my
cellular? This must be an ocean liner: when the dinner bell
rings, who sits at the captain's table?

THE EYES AND EARS OF

By the coffin, a convict
in a green jumpsuit calls to
the grieving boy: "The river of
rebirth flows to your feet.
Wet your lips with oblivion.
The woods are stripped
of color. Here and there only
a missile strike of bright leaves.
The life before life looms
and we feel ill-formed,
like bats genetically altered
to glow in the dark. Once more,
limo militias slip the state line.
Once more, cops lock up the bars
where I composed my songs,
my persona, my reputation
for a foul mouth. Once more,
desire busts us. In the
infirmary of recent dreams
I cut a hole in my neck and
pull out gobs of filigree."
Along a shadowy road,
empty cars. Not suicides,
hikers, pursuing marvels
through a forest that stops
short on high cliffs above
the splintering sea, that
mangle of wire spun
through scribble on
a movie screen, in what

could be 1960. The young
Susan Sontag dreams new
depths of pleasure, but your
escort to that concert died
on short notice. Ghost at
your ear: There is more
to this Japanese flute music,
but clouds on the horizon flare.
They remind you of the snowy
mountains that ring your
homeland as, all around,
autumn turns the shade of
a poor man's coffin, though
shiny as a leather handbag
picked up, on a bleak whim,
on a vacation junket in Prague
by a dull Nabokov; in a dim hall,
his face the pink-orange
verging into purple
of late afternoons
on the Lower East Side
once known as Abyssinia
where, called Eyes and Ears
of the King, we infiltrated
the lower orders of that realm,
sending back facts: party lights
through a black slash of pine,
angry dogs in moonlit dust.
We welcomed the festival of
rivers, catalogued all joys,

saw a moist haze melt a capitol,
turning officials to flecks of steam.
Open, eyes of sleep. We are
headless deer in a lush field.
Long ago, ever curious, our king
decreed we measure how each bed
in the land trembles with
the death or frivolity upon it.
No image eludes us – a driveway
red with coolant after rain,
alphabetic wreck in a dyslexic
eye; Abyssinia is vast, and
no word returns. *I wish*
this place would burn down
so that we can go home,
the boy in a purple soccer
uniform sobs in that corner
of my head where they nipped
a piece of skull, where I see
my own thought pulsing
around the scar. The treetops
here are a box. The sunless sky is a lid.
Here we have lived no better than
rogue bones awaiting glue in
an educational annex,
except that our dreams
are emerald-colored drinks
on a deck above a tennis court.
Ramona sets a pitcher on the table.
She says, *To sip a drink like this,*

one would live anywhere.
Jerusalem, Athens, maybe
Seattle, where the props lie in a lot
until carnival, fallen rulers of
the earth, amusements now,
with silly heads gazing
into an emerald dome of rain
across from the Outrage Center,
once the Passionate Disbelief Ward,
soon to be the Resignation Canteen,
where, praying for sunlight, you're
in a suit bought forty years ago
for a job interview at a law firm.
(Friends call it your funeral suit.)
The tailoring is all European.
The cuffs are touched up with
magic marker. Riots on the sun
invite a sleeping fit, as magnetic
emanations deepen the amber of
cognac in a glass, and you pray:
Climb the chimney, snake god.
Devour those hatchlings.
A clinic no one has seen
shines atop a mountain. Only
the very sick go there. No one
seems to come back. Not without
anxiety will a parent send a child
into that sky, in a gleaming
egg-shaped gondola
red and gray, floating like

that famous cloud of bounty
in the desert, the Hanging Gardens,
terraced with tiles, stocked with
ebony, cedar, plums, pears, quinces, figs,
grapes, to distract a sad queen.
The sky is the color of an oven
when the light burns out.
You're there, in the river, the
river of rebirth, at the mouth,
on a jade-colored jetty, well-
drenched, looking back toward
the point from where, it is said,
all this flows – a temple flame
on the coast of the Black Sea
where, night after night, the
music shears down to a single
transcendent modulation.
Though your left ear
is off a minor third,
at times a flattened fifth,
you listen. Later, at Alexandria,
you slip through the Gate of the Sun.

A SERVANT OF GOD WITHOUT A HEAD

for Nathaniel Mackey

The cool gust could be
a kiss from an overarching realm,
reaching you as in the depths of
a cargo hold where you shoot in the dark
at teeming tarantulas. The bullets
zip all around as you crouch
amid the bars of ebony hidden
in the coffee beans. And
hidden in your knee,
a ligament of cadaver,
from your honeymoon fiasco
at the alligator breeding grounds.

•

Rain crackles on the roof
over at the drug company where
you survey the ill with the help
of Ms. Ogle & Mr. Flinch,
where hope is an organism
sweeping upriver. May it soon
jump into our lungs and blind us.
But for you, now, there is only one cure:
(*a nerve in my head stops my heart*).
Bleed all over yourself until
only pretense feels real.

•

Children in a dream
collect fingernails in a sachet
and tie them to the cathedral door.
However, the book of Numbers tells us
holy toys are carried across Sinai
wrapped in dolphin skin. Only
one caste can pack them.
For the rest, to look is to die.
Words are flies, they live a day.
In the morning, under the streetlights
along the block, their bodies
will be a fine black dust.
Here at the hospital,
Manhattan Gnostic, we call
the nativity ward the doom room.
But death can be misleading.

•

As they are said to say
at the Registry of Reincarnation –
When the pouring doors open,
all slip into a cold flow. But first,
a new condo, built in an old
quarry, zoned not to rise above the rim.
And when the angel ends her opening
remarks, pain shoots diagonal,
down, and blows off your arm,
shoulder, a chunk of back.

Bronchial tubes dangle
like cut phone wires
in a house confiscated
during a drug bust, where
faces drawn on the bedroom wall
will drown in a shade called
moonshadow blue,
and children in gossamer
chase fireflies with a gold net.
There is a swimming pool hidden
under the floor. In the pool are Jews.
Idling at the door, a soccer team
made up of SS officers.
(Your neck keeps hurting you
and a burning sensation
sweeps over your body.)
Deer cross the parking lot
at dusk and devour the pansies.
In these latitudes, late light is a glory,
but night is screaming and blood.
The singer David Byrne
pauses in his immense labor,
clearing avalanche stones.
He sings a song he has written.
The verses are senseless
but the chorus is clear:
I eat shit all day,
and I die all night.

•

The sun is what upsets the air.

At night, all's calm. In the glow of
far cities, it's easy to cross the wrong
airspace and wind up carried in a beige
catamaran to the water, and sailing
toward the clouds where the
mountains are, leaving dogs
and crows around a bonfire or
a wall of smoke, across a green hill,
spilling from the torn bits of
the new cardboard card, copying
the old plastic card, copying money,
copying enslavement to birth and death,
that black road ending in a white mist
by the ruins of a tavern where the
Revolt of the Spirit was betrayed,
where what would have been
a landmark is now a men's room
with pictures spread out on the floor.
Thought turns itself inside out
in moods no medicine can master.
The kayak tips. Broken slopes glow
in the shadow of an iceberg. You
search for the root that will dissolve
the venom in you. The car spins.
Police at the scene confide: "We think
that reddish swirl in the violet sky is
a planet, but in the wrong place."
You offer: "This may be due
to a talisman I buried in a field,

the Virgin of Guadeloupe, half-eaten
by scorpions drunk on occult starlight."
A chill frees the leaves of their green,
while over at the aquarium, the dolphins
are eager to please whoever holds
the fish bucket. Despite all the
disillusionment, you resume
your petition to the Firearms Board,
but cursive is a joy your lazy hand
fails. Your words are no more
than a funnel cloud, sucking dust,
paper, and unsecured items into the sky.
Leaves glow in the wet light.
Salamanders of lightning shoot
down the sky's wall. A beauty from
Brazil slips a vanilla bean in your
coat. The room turns the color
of a swimming pool. In 400 years,
the boat of absolute belief will cut
back across these waters. Will
you be ready to board it?

•

Someone with nerve
damage will indicate an icy
night blowing through the hole
where your gut, lately excavated,
hides a last icon from looters

quickened, as are you, by the
only conclusion the cold
allows: *I will leave here now.*
But since the journey is like
no other, *here* has never existed,
this lakeside hotel, at cocktail hour,
with parabolas of silk falling at dusk,
where, in a dream, you enlighten
James Schuyler: *I just got how
much painting means to you!*
And he, quiet, polite, a bit curt:
So, you finally figured that out.

·

Shoot, blue lizard, up the wall
of a festival tent. A classmate dies
in flames at the World Trade Center,
then reveals a secret room in the ruins
for writing down dreams. Though
never quite likable, he does you,
now, the courtesy of drawing,
on a chalkboard, your future:
a spatter of red dots, a chemical
glow over a track meet in the forest
where, while waiting for runners, you
chat with an engineer who puts
hatch doors on spaceships.
The sun spider climbs a tree,

its legs eight blades of light.
Meanwhile, at your job on the pier,
Mohammed, an electrician, gets
snatched on payday by the FBI.
Who, now, will help rewire your
garage, help you explode your life
into a million glittering bits, help
you step, exhilarated, through ashes,
help you live like Mahler on a moon
of Jupiter, in a house with a patio
enclosed for half the price of
a room? (You'll have a garden
around you, all year long.)

•

In the grove: two girls,
jogging, not long dead, two
corpses like a breeze through
autumn leaves. Naked, starved,
they stop. The air glows silver.
Day looms, overcast and hot.
One of the girls says: *The Nazis
are back! Don't get caught!*
The other seems eyeless, her
eyes are so dark. (You almost
know her.) Pointing to her ribs,
to a straw stuck between the bones,
she says: *This is how I breathe now.*

Then they lope down a hill
toward some brush, toward
what would be an oasis of
rebirth, were this Egypt.

•

Back then, the dying lay
hypnotized. We let each see
his desire. (Dialysis took all day.)
One might love making birdcages:
Step into your shop. Another,
crave heaven: *Climb this street —
see the far-off glowing wall?*
We're out of your wine,
the waiter concedes, words
cut up in clatter, face starred
in disco light from the dance floor.
But we have another, a lot like it,
from a vineyard called *Clouds at Night.*
Sure. Why not? But he goes on:
There will be a gap in the black
when you die. But I see you are
board certified for instrument flight,
for the joy of seeing miles in the dark.

•

The Days of Awe dwindle.
Leaves turn the color of bourbon.
Hogs tremble deep in their guts
as a moon, unseen for 47 years,
announces "hawg-killin' weather."
What dark force has deleted
the e-mail refuting our death? What
devious legion from your past drags
out the nickname you'd hoped would be
forgotten, o "Pythagoras Reborn"?
(On the news, Mayor Giuliani lets slip−
the surrealists are back from death.
They have agreed to live here,
in New York City, under cover,
for the foreseeable future.
Reporters stir, astonished,
shouting out names. Breton?
Artaud? Desnos? Éluard? Daumal?
Perhaps the long lost Pierre Unik?
Marcel Noll, not seen since
the Spanish Civil War?
The mayor lifts his hand:
If you knew who and where
they were, he cautions, it could
compromise their dreaming.)

•

Elsewhere in this video game
called Acts of the Apostles,
an elixir wagon speeds
into the next county, just
ahead of the sheriff. The voice
of W.C. Fields rises in the last
flickering of the day's flame
over a forest of thirsty snakes,
at the hour the grandson of Herod
kills the brother of Christ.
(I open the home testing kit,
curious if new life is inside me.)
While elsewhere in this Valley of
the Kings, a circus tumbler turned
desert adventurer may yet find
the tomb of the true god. Pray
with me: Let our viscera
win rebirth, if only as bait
in that final pit bull match
out behind the military school.
Leaves now are turning the color
of a lemon cake made for
a birthday, if this were
Honolulu, if the night sky
were a blindfold, black
as the thicket from which
Abraham pulled the lamb,
black as the bodice of a pop diva.

•

Make me the saint
who inspired an opera
based on a blood test
done during a long stay
in a mental hospital.
A snake shivers beside the road,
a red bird in the green leaves.
Even without such grace,
the temple of the sun seems
not just a ruin of stone and clay,
but a hollow for singing,
days on end. Our destiny
is to rot or to ride away
like seeds in the grille of
a white van. On the side,
red hill, red cross, red bolts,
in the white sky, the name,
Golgotha Electric, etched
in a red sizzle. Dreams
lead still deeper, but
to a chicken coop? Yes.
And the couple in a huff?
They were once royal hosts.
In a garden now, with an angel;
her gown's a scintillating shade
of orange. An annunciation
seems to be in progress.
Our words are audiotape,
she says. They are spliced,
played in reverse, then that

tape is taped, sped up, flipped
over, until our mouths
run the words backward.
We move our lips to match
the senselessness of all we say.
But that is not always true
in these violet shadows,
where dew on a leaf is
an image of fate and, one
morning, a white stone, an egg
from a magic sack, appeared,
left for starving children
lost in a forest by a magdalene,
wild red hair in the grieving hour,
though the text goes on to
foretell light in darkness,
at least around the Dead Sea,
where the salt is 41 parts per 1,000.
By day, copperheads hide in the ivy.
At night, they slip down the wall.
Our salvation? String them up
in the school gym above the
purple gourds on gold crepe
heaps beside a skeleton.
The Halloween dance whirls on!
Let a few glimpse in the grain of
those dried-out, flattened skins
the omen of the hourglass.
In the film by Harry Smith
called *Heaven and Earth Magic*

a brain's cut open; the patient
is awake, and chatty, hallucinating
in response to various stimuli.
(Which is to say, in Dixie, much
is forgiven if liquor is involved.)
So you dream there is a massive tree
out of some tropical rain forest
falling in a New England storm.
The stump shoots up white,
raw, from where it never grew.
The bulk of this moss-hung world-tree
lies across the street, in the yard of
the Burkes, an Irish Catholic
warren of a dozen-plus siblings,
where you once exulted. The kids
would line up for haircuts
first Sunday of the month:
oil drum burning with trash,
and the father, scissors in hand,
tossing trim to the flame.

•

Erupt, sky. Nothing's for sure.
Only the speed of dreams pouring
through mountains, above some
channel, above inlets
glowing, phosphorescent,
all those sightless millennia

before the evolution of the eye.
Then translucence, a lens spilling
fire into our cells. Biochemistry is
running wild. Our retinas
upend the world, our brains
catch what points to heaven.
Gnostic optics! So that at night,
eyes closed, dreaming, we see
Persepolis, or a radiant cocktail
hour in the Renaissance. Two lovers
walk like apostles through the square.
Arms at her side, slightly forward,
palms up, the woman marvels
at the warmth on her hands,
pale as blossoms in the yard of
the secret church, where the only
shadows will be her black hair
falling over her shoulders.

•

Salvation quells the anti-flash
of daylight. The cactus with the
wounds of Christ, the crutches
pitched in holy mud: my dead film
is no more, now, than a black ribbon
pinned on a mask at a festival.
The pastry shop door says
in Greek: closed. Though walking

headless on a road above the city
I "see" burning shreds of cloud
in blue-gray creases of snow.
Cloudburst. Wet leaves are flames.
Flames are pottery bits in a plowed field.
The coreligionists reach the sea.
Mottled dogs dash into waves.
One, from the half-sunk ruin of
a military installation, yips
for a Frisbee. The sky is
as black as roof tar in a vat.
A crow stares from a pole.
Boil over, earth. *The snazzy
tiles along the rail are salvage
from the Armada,* says the
dead housewife, on the stairs,
naked from the waist up, her legs
two trees, twisted into one trunk.
As you can see, she jokes, *giving
birth was no real vita nuova!*

•

You may feel like "a corpse
with insomnia." Her scarf touches
your arm. The world's too bright.
The sun wobbles. Leaves of flame
shed in the chill, while, open
on your pillow when you

awake, lies a Buddhist book
with orange fish in a green pool
and black camels in a desert.
(It's Daylight Savings. Hit fast-
forward.) The world's too bright.
The dream murals bleach out in
your cathedral-sized closet.
It could be said, each morning
detonates the last, the petals
are a red smoke in the branches.
It could be inquired: should you
wear robes today, walk through
the world with bare feet? You
were enjoying a waterfall
in a mall. The roof blew off.
Moonlight mixed with a rain
too fine to ripple the liquor
in your glass. But now it
might be urged: go online.
Type in: "cessation of sensation."
Wait to be called, to a forest, to
a creek the shade of snake spit,
where life is not a chasm
or a pier ending in a hurricane,
but a surprise kiss that finds
you in a corner of a party
as others are distracted by
fireworks through the trees.

WHICH IS TO SAY

in memory of Stan Brakhage

He leaves a paradise of

rapid bursts of light, an epic
of perception, he called it,
a heaven that hurt your eyes
with cruel Persian pleasures.
Which is to say, you awoke, wires
along your arms ending at right
angles inches beyond your hands,
shooting fire. It seems you were
that very night a partisan in
a military unit pressing through
the hills and villages of Bosnia.
Which is to say, Berkeley, and all
those chemo-sweetening brownies.
And when almost every blood cell
was dead, at a table with a mat
that was a map of the nation
I saw, in the border of Montana,
the exact profile of Richard Nixon.
Lord, was I stoned! But this must
also be one of the ways, I thought,
the dying experience "insight."
Which is to say, our souls are
soaked, soaped, spun, yet to be
boiled in the typhoon of rebirth.
We remember we came out of
an infinite void. We remember
multitudes who did not come to be.
Which is to say, in page after page

of the book I am writing, I exult
as old beliefs die. Which is to say
a child speaks in a dream: *There is
a God within reason,* an orange slash
in the roof of cloud over a lake coated
with a thin fire, as are the mountains.
A single heron, glimpsed in the dark,
ripples for a second then is gone,
into the shadow of the ripples.
Which is to say, I am due in
Pasadena for a three-day-long
corporate review. Much will be
decided. I will face four trials,
the first by the top guys, the next
by peers, the third by the lowest,
and, lastly, by the hotel bartender,
who lewdly banters with all in
highly idiomatic Portuguese.
Which is to say, after death
there will be holes in the ceiling,
wires falling down in an office the
tenants lost the lease for and left
in a hurry. Amid the empty all of it,
an unmade bed, on which you
stretch out. At night, water
slides down exposed girders,
pools shine in the dark, snarls of
electricity shoot blue fire down
the coils of wire, out over the floor.
Which is to say, you look past

the glass walls, the other skyscrapers
sinking into the dark, and think:
This is what philosophers call
"our common experience."
Today must be a mountain.
I am chained at the base of it.
This must be how my father felt
working for the CIA in the Congo,
or was it in Romania, when he was
a sales rep for what they called
the "Sunbeam Company." Which
is to say, there is a path around
the pond, a park around the path.
Every evening hundreds are out
walking in a circle, looking
at the light striking the water,
the pond with a band of pink in it,
of evening sky above the mountains.
Which is to say, dirt gives color to the air.
Dirt makes the clouds magnificent.
This is confirmed by a Hebrew
phrase found in the book of Job,
rendered as "dust and ash."
Which is to say, in a café in
Tacoma a mother tells her son
about the pull of the moon:
Mostly, our brains are water.
When the moon is full you can
close your eyes and time travel.
But when the moon's this new,

move as slowly as you can.
Make a cave of your body.
Curl there. Be quiet. Wait
for the light to return.

HEAVEN AND EARTH MAGIC

Have we found, some ask,
the tree that is a cabinet with
a magic chemistry set inside?
(I am lost in a catacomb under
a cathedral in Brazil. At night
gates open onto a gloomy sea.
Secretly, the slave ship arrives.)
In this movie, Manhattan is
ringed by snow-capped peaks.
Fog floats over blackened hay.
A small girl in a violet dress
puts a fishbowl in front of
a blazing slide projector.
The shadows of small fishes
swim across scenes you are too
old to hold to in your hope.
In this movie, they speak
pidgin Finnish, this film that
began, rather surprisingly, as
a how-to guide to emergency
childbirth. On the beach,
despair is the one true spark
in a world of pure carbon.
My senses are still too alive.
In this movie, winter light
has never had such power,
which is to say, romance is
not promised: unrepentant
sensualists lie faceup
in the mud: large stones

pin their limbs. Under
an old-fashioned streetlight
a beautiful, tragic college girl
shows you the purple scar
written across her wrists.
She says: *My nerves are wires*
that have never conducted
such flame, until now.

HEAVEN AND EARTH MAGIC II

Flashback, the Silk Road,
in Zeugma, once a garrison
of Rome, the hills hide mosaics.
Kids in puffy blue tubes walk
in road dust down
to the shallows, trailed by
emerald-green insects
with gold heads. The shape
of the sky will soon show itself:
patriarchs clustered around a dogsled.
A boy in regal headdress sits naked.
A long wooden rod attached to
his penis is about to be twisted.
The bay sparkles despite
the moody overcast sky,
the debris afloat, up there.
Poetry, André Breton said,
should be an advertisement
for heaven so compelling,
everyone will queue up
for suicide. Perhaps here,
by the margarita fountain in
a pawnshop, as dark, broken clouds
rush into a twilight that stretches
from Zimbabwe to Colorado,
where the dead take turns as a snake,
a deer, a boar with paper tusks.
And men set a kayak
in a pool of light by a girl
on a cell phone at a bonfire.

This must be the moment
our lovers fall in love,
arms looped, hip-deep in low tide,
as 56% of knowledge fades,
another 10% goes in the glare,
and the rest is a ripple of ether
or a night sky of stars,
an off-kilter constellation
where a fox licks the face of
a farmer asleep in a hay bale.
And the stones are volcanic.
And words are water, are steam
in a sweat lodge dark where
what is said, is truly said:
I have invented a new kind of
camera, close to the old pinprick model,
but with shadows like a purple
and pink crater with
surprising pockets of ice.
As for New York nightlife
after the collapse of the towers,
what can one really say?
Dull as a Communist-run
disco in East Berlin.
Where in the world are we?
Where the end is at hand because
a rabbit falls asleep under a mango tree.

RED FLASH ON A BLACK FIELD

RED FLASH ON A BLACK FIELD

I

Trees flower.
The air has the reek

of semen in a steam bath.
Though, like a Turkish warrior,
 your shirt is stitched
 with lines from the Koran.

Still, each hand-painted square shows a leaf
cleansed of green, the mesh of
the veins drenched in gold,
the stem a twist of
gold, and, dense glitter,
the letters on the leaf
the call of Love.

Gather the family, then, one last time,
in a summer house, sea and
island out the window,
the window all orange,
as a fiery square the size
of a suitcase moves toward
you across the water:
a package has been sent
from the nuclear plume
on the horizon.

 While, would that be your mother,
a woman in a wooded spot, by
a dark, dried-up brook, saying
she, too, failed to redeem

the dead:
I tried. I named
rivers and meadows
after them. This desolation
was one of those flowing places.

•

Fire ants stream along
a wire into a house.

•

(The Earth
keeps unveiling new
 altars to Hypnos.)

•

But we have yet to
evolve, not even into these
lithographs,
 these heads without bodies,
tilting up: eyes open, pupils wide,
turned to the moon,
 to the Mare Crisium
or whatever else might be

snagged by a telescope

in the Andes, how
all matter is drifting away
 − once again a cloud
as when burning from the burst,
then cooler, blowing through

trees, green or dried-up or
opened by lightning,

wet inner wood a deep
orange, beautiful as a beetle
at work in the bark.

 •

Ophthalmologist
Nietzsche, in a dire mood,
 tends a rebuke:

gifted with greater subtlety,
 you would long ago
have noted all is moving
like old newspaper,
 which, burning, shrinks
along a path of magnolia
petals leading to a porch
where young girls eat

the spongy core of
 an unknown flower,

rather than be, as you are,
misled in your logic,
 like that unwise couple
 who thought to flavor their tea
 by boiling peach pits.

II
On a mesa with
magnetic properties
long held to be healing,
a blue butterfly pops up,
dazzling wings, huge,
the size of a hand.
 And later,
over a plate of ice cream cake
at the adoption day party,
comes the Second
Symphony of Mahler.

•

Sunlight brushes
snow from the mountain.

•

Last night, drifting across a lake.
Deep within the cold and moonlight,
strange images were rippling
on the water.
 It seems
this may yet be a pastime
once popular in 19th-century
Scandinavia,
 "dream camping."

A group of three lie
faceup, heads together,
bodies in straight lines

to the points of an imagined
triangle. In the center of
the space ringed by their heads,
they put a loaf of bread.

Then, drifting off in
this wild flowering endless
meadow inside

the Arctic Circle,
they round the world
in bursts of radiant sleep.

III
A desert above a river,
a heaven beneath a mountain.

A boy runs laps in a wet field.
Men move a huge window into a pit.

A neighbor showers, lies down, naked.
A breeze comes by and cools her.

Vine of a flowering weed weaves
through matted grass,

a green thread through drought fringe.
Pull the thread, a flower slips into the mesh.

A lake beneath the desert,
grain in a field above a cloud.

A flaw drains light from a dog run.

The mud is a treble of mutts.

One ear hears the gentle stillness of the night,
the other hears troops take a beach.

Together, ears hear the sound of men
singing "Dear Father," though

clearly not in English.

A spaceship settles
in a vitrified wood.

The chief mechanic
is thinking out loud:

some catastrophe beyond any
ever known has brought

ruin to the Venusians.

The glass trees gleam.
The ground is black, crystalline.

Later, horror: up a dead-end ramp,
swirling, tar-black, chasing the explorers,

the living lava snags the foot of
the only woman on the crew,

the beautiful and tragic
Asian doctor, whose
husband died

in a mishap on the moon.

Quakes break out.

The planet
will now flip

gravitational polarities.

89

This will fling the ship
back into space.

I am on earth, my name
is Happy. I have just,

with my sisters Melody and
Sunshine, returned from Crete.

We saw canals, minarets, and castles
with marble staircases to honor the Crusades.

Medieval, we wanted to believe,
especially the mosaic of

black and white pebbles
 on our bedroom floor.

But it was all, it turns out,
built by Fascists in the '30s.

In a hotel once a harem
we had the top floor

looking at the three-story
head of a hero, traffic routed

through his eyes, out his mouth...

Vapor loops over the lake.
At the picnic

a doctor places a finger on the side of your skull.
I can tell you which nerve is causing

all this havoc in your head.

Across the water,
the mountains seem empty,

like a synagogue no longer in use.

(All the Jews have left.)

Later, on the wall, a picture of a door.

The door is green. In another
picture the door is purple.

Both open onto
a world soaked in ocher.

The children can still sleep late,
but soon school will be starting, with new kinds

of math, and facts about other places.
Questions will arise:

What is life like
in a mighty port city?

What is it like to have
an inflation rate of 700% and
the army in charge?

When, in a rampaging cart,
will Deity X arrive,

and his rodent army?

Why does the river flow both ways at once?

(Because sowing and reaping
are perpetual, there.)

After the flash flood, you can smell
the fields from the truck stop. Mountains,

clouds that glow like
an electrical coil.

We breathe, eat, sleep, and see,

a cinch of nerves,
credit rating, and fate.

It's a cool day in the primate house.
The sky shines, African green.

IV
Downstairs, through the ceiling,
water drenches a high-voltage console.

Fortunately, for now, plastic sheets and duct tape
funnel the torrent into a bucket.

The event manager can't find a plumber.

So: empty the bucket, over and over,
in this basement room

or the electricity will climb up

the torrents of water
and electrify the pool

in the lobby above

where movie and rock stars
arrive for the gala opening

of the famed designer's boutique.

And if one of these celebrities,
if Elton John, say, in passing,

dips his fingers into the

shimmering black oblong
of water lined with

mannequin brides,

if he just brushes the gleaming

wet stillness

history will list you
as the man who

 murdered the man
who helped the world

endure the death
 of Diana.

 Later, night
finds you on a fire escape.

Each step is lit by a candle.

At the top, a party is going on.
All have gathered to give thanks

that the gods have finally fled the world!

Sam and Jim

 were talking about it

later, in the steam bath, where
each kept introducing

himself to all those there,
first with one name,

then with the other.
Perhaps neither was either

Sam or Jim,

what did it matter, every-
one was having such a good time,

though all this was
too soon since

your return from Jerusalem,

where you saw a red bird

in the green leaves

in a halo of straw-colored light,

and just before New York, where you saw
some jump, and some not.

Orpheus, on the other hand,
could simply be asleep.

An aura crowns his head.

95

Ethereal flames and night sky
surround him.

His genitals are tied to his lyre
by a strip of cloth, a wisp of smoke,

or some kind of astral snake
with its tail in the stars.

True, he's dreaming

what a tree might feel
 torn by a tropical storm,

or a sheet

thrashed into a ball at the edge of
a bed now empty save for the parallelogram

of white silk cast by the skylight.

Though what happened to that orgasm
is a mystery to them both.

It seemed to happen,
 but then to not.
Pleasure, they agreed,

had, at that exact moment,
 repudiated its nature

and was wandering
 loose and lost

inside their bodies,

like a wave that
doubles back

forgetting to hit the beach.
Whereas farther out,

 deep under the distance,

giant squid glide through
coral reefs, changing their colors

in a flash, and the nerves
of jellyfish

 communicate

without the

dreary interference
 of a brain.

V
Overhead, magnetic fields
tear and mend and flare,

prominences, coronal loops, granules,
eruptions of x-rays, all going out into the darkness,

damaging satellites, bouncing
off a kaleidoscope of

angles and edges, reaching through
your eyelids as you sleep, into your

eyes, through your eyes, into
your thoughts, through

your thoughts, which likewise
burn, roar, and crackle in the void

at 27 million degrees
Fahrenheit. In the morning,

open door, hummingbird, black and
white stripes, a long yellow bill,

hangs for a second in the air.
All's at once, and only once,

says the quick of its wings,
but the once is endless.

VI

Edwardian nymph, eyes closed, head tilted dreamily back.
A man behind her buries his head in her hair.

She holds the hand of another man
who himself has his face turned from her.

Over his shoulder, another woman,

leaning close, as if to whisper,

and on the other side of

the sculpture, the two apparently
divided confidants

are tenderly touching.

It's a dance of stone called
The Solitude of the Soul.

It made of Chicago
a sculpture garden, though

Chicago was still a slaughterhouse,
hogs strapped on wheels,

gutted alive. And so

before the bookcase
could be built

we had to sandblast
blood from the walls.

•

The first heat drives legions to the lake.
The water had just turned.

The freezing deep rises.

•

The living room
 still smolders.

Clouds of ash.

A ghost, singed and gritty,
in clown makeup,

asks: What are you doing here?

•

I cross a volcanic crater

in a rainstorm, warm steam rising

from openings in the earth.

Cross a strafe of gray through black,
crystalline flecks of ruby in the

whiteness of a beach pebble
from when the world was molten.

I now know the

origin of the earth, but
 could you explain to me

the continuity of the
generations?

·

A boy looks out
 at the others

on the ball field. He wants to join them,
but his head has become

detached
from his body.

The head's beside him, on the bench.

The body loiters beside it.

The father feels bad.

He'd meant to take care of
the head thing
 earlier in the week.

The head's angry,
but after some bitter complaining

about being left out of the game,
the head recovers

by and large,
the amiability

that had so graced
the boy, back in his pre-

decapitated life ...

 •

Later, you awake

above the tree line.
 Mountains unfold.

Bluish-gray shadows fill the evergreens,

while there beside you

in the ski lift,

a woman mentions an exotic spa,
what it's like to soak

in hot springs

with two warm stones
on your closed eyes.

Her eyes have glitter around them,

as if she had just come

from a fantastic, all-night
 New Year's
 dance-o-rama.

She takes your arm,
 rolls back the sleeve.

You know how we are mostly water,

right? You know what it takes to
make water ripple, right?

Not much, right?

She drags her finger
all down your forearm. See?

And so a ripple
 from beyond you
 passes through you ...

 •

(Soon the night sky

 will be astir with stars.

We will discern qualities

 where none now are.)

VII
To hail from those

who walked the burnt earth,
are still so walking, feet blackening,

even now, embers in ashes, earth still hot,

not a preparation for planting
or clearing of the wilds −

to be of those whose feet
are not yet blackened,

those for whom the earth is

about to be burned, homes and fields
of Mesopotamia, be of

those who will shortly walk out

through hills, rivers, roads of ashes
under a sky of ashes, the sun

a last burst of combustibles flaring overhead.

Or, of those here, wind warnings −
trailers snap and scatter.

Windows fall in a field.

A tablecloth drops in a lake.

Or to hail from Dra Mi Nyen,

where all live in luxury
a thousand years

but in the last week of life

a voice whispers
to each how he or she will die.

That person suffers more in that week
than you or I will in a lifetime.

•

Eons before this life,
 didn't we open our eyes?

A blue salamander streaks under the door.

A luster of coal dust in the air
around the mimosa trees.

Rain silvers the world.

Hours of silent chanting come to an end.

Believers stream into the sepulchre

or is that a last laboratory
closed by the state of North Carolina

from an era when eugenics took our breath away

like kisses at a party
 when the lights go out?

My mind is
 mismanaged by

two class geniuses
 from my old grade school.

They want credit for their terror,

Lizzie tells the court.

(Her kid brother, black
triangle on pale forehead.

Known in the neighborhood as

"Little Hitler.")

Lizzie shot the manager
at the Eveready battery plant.

She also brought, the paper said,
 a Molotov cocktail to work.

Her delusions are more
 elaborate since the murder
 and the firebombing.

(Her sister was pretty
and was often,

 come evening, out on the porch
 talking to the boys.)

Tonight the clocks
 jump ahead an hour.

(Children may be irritable
 tomorrow, in Sunday school.)

The pollen is lime-colored powder after the cloudburst,
coolness and sun and a swirl of yellow dust around the
sewer.

Pakistan wants
 a Muslim bomb.
 Within its defense

protocols, however, are traces of a Hindu past.
The three criteria set forth

for justified annihilation

are those given

by Krishna. (Effloresce, light of

a thousand suns,
devour their armies.

The known is in your maw.)

Moreover, within the history
of interpretive disputes

occur concessions
to Buddhism.

It is not impossible
to compose a rationale for
a Buddhist bomb.

•

Wisteria petals foam on the rocks,
a purple waterfall in the middle of the air.

•

Tank Buster Palace Buster Bunker Buster

Tunnel Buster Market Buster Ridge Buster

Koran Buster Torah Buster

Murrain and Boils and Death of the Firstborn Buster

Yacht of the President Buster

Pear and Quince and Tamarind Buster

Inanna Buster Tammuz Buster

Trench of Burning Oil Buster Tree of Paradise Buster

Jesus and All the Saints Buster

(The sky is a shimmering curtain of poison splinters.)

Car Battery Buster Jumper Cable Buster

Sufi Buster

Zoroaster Buster

•

Fields aglow with depleted uranium.

Citizens of the future, you arrive without eyes.

•

Later, in Manhattan, in the party-going
meander, you've lost a package.

•

Off the coast of Brazil, an island
cave wall streams with sheets of copper.

Each dawn, the sun god sees his own face.

Put another way: every day a second sun
rises from deep within the earth.

•

On TV, it's the Branch Davidian

"Reunion Special."

Out of red and black lines
in a child's drawing

a ladder rises to heaven.

Cut to: smoke across a dry field.

Flame was long ago translated into tongues.
Today we translate the tongues back into flame.

•

(The wedding night of
earth and sky.)

VIII
Later, walking through grass along the side of the road
in the sun with the rest of the track team,
a boy swings his arm.

Elbow catches the mirror of a passing car.
The mirror explodes: diamonds, the empty shell
clatters on the road, the car slows.

The boy sees a faint mist of blood
 beside him in the scattering glint.

He turns into a fox and disappears

into the tall roadside grass.
The grass turns a smoky blue.

Then you step into a spiderweb,
midair, dozens of yards from any tree.

It lies across the face, arms, back of head, chest,
nowhere seen, but with every motion, more present.

A wisp brushes your cheek, your lips?

Can't be sure, but your nervous system
feels enhanced. Something must have bitten you.

Ripples, out of nowhere.
You are imperceptibly
enmeshed.

IX
The mother hates the military.

She insists on private DNA testing
on what is said to be her son,

the Navy pilot. The pilot's wife is
so incensed about the extra test she tells

no member of his blood family
about the special memorial service

on the tail end of a destroyer in the Pacific.
But then comes Arlington, a full

military funeral, three decades late.
We're walking behind the caisson.

They shoot the rifles. His whole
squad from thirty years ago is there.

The folding of a flag is much more
intense than you might think.

Next time you see it on TV,
watch their hands.

X

The colors of the sun have reached the earth at last.

All the trees show it. The world is a waver of reckless flame,

even at the Arctic Circle, where you stand
behind a rack of dead geese,
on the hunt with Spoonbill Bob.

Behind the sports complex
 on the pier, refrigerator trailers,
 forty-seven of them,

are hooked up to electrical cables.
They are humming, and cold and full

 of body parts for the DNA team.

We find we are far now, very far,
from the enchanted mesa once

Klimbed
 by Krazy Kat.

In fact, we find we are huddled
 in the hollows of a higher life,

 in a glowing, unbroken shadow
where every day brings new shades to the forest.

Rain makes us forgetful.

Glistening dissipates sorrow.

The clouds say:
we want to be a tattoo.

We want to be written into
 the skin of the world forever.

The clouds say:
we want you to be
lost in your love for the sky.

The sky is too busy burning to hear all this.

The clouds say:
 remember us

as a skin-deep hour, as a needle,
as an indelible, fantastic ink,

as a rendering of

a man and woman, as they might be seen in

a middle school biology class wall chart
in an empty classroom at night.

Arms around each other, kissing,
but they have no skin.

They are waves of tendons,

and veins, and sparkling nerves.

A friend has a new job.

He sits in a booth and fields phone calls.

The booth is the kind in which
 musicians might practice
 feverishly for a concert

but in this instance
the booth is devoted to

phone sex.

He manages his half of the salacious banter
while slipping his hand on and off

the receiver, so that

the illusion of passion is maintained

while he simultaneously chats with us.

He says, looking down the hall of
endless enclaves of

phone-sex professionals:

"It's an orgy of people, half

of whom are never here!"

Let me start over, with a kite flown by a boy on a hill.

The kite breaks off. The boy runs after it.

He runs by his house. It's on fire.

He runs after the kite, it lands on a boat.
He gets on the boat, the boat starts to sink.

He jumps into a lifeboat. The kite breaks off,

flies to an island, where the captain
(who was also in the lifeboat)

sets up a new house.

The right side of the kite is blue.
The left is red. The middle is yellow.

•

It has been suggested the chemicals of
the dream remake the body of the dreamer.

•

The king of the monkeys
sees, deep in the well, the moon.

He orders the other monkeys
to dive into the well, to save the moon.

The tale does not end happily.

·

These days are a tangle of trampled light
and a smoke-colored elsewhere.

·

Are Xanax

 are Celexa

·

Are a shelf of low
 purple-gray clouds

 that ends where the sky is pale orange,
 verging toward where the sun will be

when the planes lift into it

or else chase the falling darkness
 that slips off the earth like a magician's cloth.

•

Are Celexa

 are Strattera

•

Are a trick to pass the time.
 Take a pack of matches. Tear off the flint.
 Fold it like a tent. (Keep

the flint on the inside.)
Pitch your tent,

exile, wanderer, gypsy,
 Arab, Jew, on a quarter, and burn it.

•

Are Strattera

 are Xanax

•

Are the smudge under the ashes
on the silver of the coin.

Are the sulfuric grease.

Are the smear on your

forefinger and thumb.
Turn out the lights. Rub your

slicked fingers together.
Your fingertips

will glow.
Turn on the lights.

The glow turns to smoke.

•

Are Xanax

are Celexa

•

A waft of champagne fills the cabin of the boat.
The expedition to the hidden waterfall has met with delay.

•

Are Celexa

　　　　are Strattera

•

Are sky-bruised petals
like the hand of a fire dancer
so much of her skin open to the burning.

•

Are Strattera

　　　　are Xanax

•

Most of the time electricity
just bunches in the air.

XI
For ten days
the amorous slave

 is allowed to love,
 love none other

than Cleopatra, but then: he must kill himself.
When the time to die comes

a muslin-wrapped
devotee of Isis

pours out a cup of wine
and asks the goddess to save him.

Flash of a dialogue card:

"The wheel wobbles
 as the wheel will."

In a dream a boat is moored to a hotel.

(A canal cuts through
the middle of Manhattan.)

Meanwhile, the afternoon rain

pouring through the ceiling into a house
in Guatemala looks quite beautiful.

A film of silver gently pulses

across the lilac paint.

The gleaming wood floor
catches strips of

lightning from far
beyond Pluto,

from where the sun
appears as only

a pinpoint mystery
 in a frozen world.

What good is a life of
 stealth, lived in shadows?

White dog on the hunt,
 as you creep, you blaze.

In a cold, prolonged gust
 the tree shed all its leaves

−a torrent, a torment of
 pale evacuees

rushing along the gutter

under a charcoal sky

by the café
where you wait for

a secret confidante.

•

"Tell Israel the ban on idols
no longer holds.

I am rescinding
the second commandment,"

God says, in a dream.

The new tiles on the floor
are a color called

"Moonlit Bones at Midnight."

The universe
is an entanglement.

Manhattan touches Mozambique.

Unity will be recalled
across

all divergence
once we climb up 125
 hundreds of steps.

(Other temples
are huge stones

in a green tide of trees.)

There is only one position
where I don't feel pain, but I am

in that position now,
and I feel like celebrating.

My name in Hawaiian
means *black star.*

Light-filled arrows
 shoot through my heart.

A woman walks through the crowd,
holding over her head

a dragon of glittering red beads.

My neurocircuits
 have a purpose
 but no goal.

Later, in front of the empty house,
you fall sobbing on the street.

The trees blossom hourly.

The dullest branch
is a festival of petals.

And from off the floor of the rental car,

a pen drifts into my hand.
On the side of the pen it says:

For all your
aerial photographing needs:

Sky-high.

•

The VC pull the smoking bones
 of the pilot from the treetop wreckage

 and sell them back.
That bravura in the bamboo
could be the sun, could be

the mind turning to
phosphorus,

which means you are

receiving thoughts from afar,
from someone inseparable from you.

Thoughts
are like a bird seen

in the depth of a dark wood,

feathers so vibrant they seem chemical,

like someone caught the bird,
dyed it, and let it go.

·

(I am your secret valentine.)

·

The valley floor
glazed with ice makes
the slopes an acoustic chamber.

The stones sing
 high above the tree line
 where, as legend says,

the moon tore loose
and left its light behind.

•

The bike mechanic
pries the flat from the rim.

He bends the tread inside out,
holds it up to the window.

He shows everyone
the fissured brilliance pouring
 through a sky of black rubber.

•

Dawn
in Baghdad,

the first of many flashes.

We witness history,
the beginning of a war.

A deserted overpass

filmed with poor production values.

Like footage
pulled off

an ATM security video.

•

Poetry lives on placards
hung from the ceiling on string.

A large fan is blowing
directly at them.

Should an observer grow curious
he or she can walk around, look up,

try to read the placards
in some kind of order.

What I tend to say
is twisted all around,

like lemurs in Madagascar
who suck millipedes until they lapse

into a hallucinogenic trance.

•

At the edge of the Arctic Circle,

Spoonbill Bob presses on.

He harries his band of hunters
into the imperishable

nub of twilight.

We must begin, he says,
 to think like birds

and, in our minds, to fly
 above our own bodies.

IANNIS XENAKIS

A crackling sky.

Zarathushtra greets him

as does the shah,

amid screeches, pings, clatters,
thuds, wails, sizzles, pops,

creaks, whispers, beeps,

tape loops that sound like

the lament of Cassandra.

Beyond the last impurities of
ears, those slips of skin,

those skull holes,

Iannis Xenakis

is now a blip, a breath of
celestial electronica.

Meanwhile, in the orchard
where my virginity

drifted into nonexistence

an office complex glows.

My mind is a hive.

My thoughts are bees
 bereft of their queen.

In school, they called me
Sky High, Ether Girl, Ariel,

not because my father
was an airline pilot,

but because I want to rise to
where colors pass

directly into the mind
without the

intrigue of the eye,

though it means I must always
 return to the world

with no proof of

where I've been.

·

Xenakis has dispersed
 far beyond Persepolis

while on earth, a woman walks

up a driveway. *I dropped*
an earring in the gravel here

twenty years ago,
but just the other day,

 I found it!

The night is alive.

Fireflies are airborne

salamanders returning to the sun.

A rabbit slips through the vines

outside the estate sale in
a dilapidated

hacienda

in Albuquerque.

Up for bids: a mask.
The face of a mother, with

white horsehair falling forward in locks

and pale blue stones set in the eyes.

The likeness was eerie.
It was a tribute too vivid

to hang in the hallway where one

might come upon it face-to-face at night.

Often at this time of year

there appears a fiery path to the beyond,

an orange streak on the water.

The shrubs are full of

fruit never so ripe as now.

Take a carton to the fence and fill it.

The birds are announcing
 all that is here.

Don't be hapless,
a latecomer to the feast.

 •

The wave looms
hundreds of feet high,

surges, gray-green, splinters,
falls over you; a hollow

forms inside the cascading
water as, dry and

astonished, you look up.

The apex of the vault fills with light.

A thought occurs: I am

inside a cathedral
of falling water.

 A fray of froth
across the ceiling

as the water holds the shape of
the force moving through it.

Then, in a flash, there you are,

where else but in Grand Central Station.

From the crowd a woman holds out,
wrapped in cloth and apparently

long hidden in her purse,

a piece of glass.

It's a shard of a stained glass window,
you immediately intuit,

from the greatest synagogue

in Vienna, a window utterly destroyed
in the Second World War.

She has been saving it,
she says, until now.

•

They are reassembling
the great window.

•

Incredibly, every chip of glass still exists.
The keepers of the pieces have been

summoned back to Vienna.
But for you, your destination

is less, what, monumental,
less grandly restorative:

an unheated house on a fjord,
 steps lead down to the water.

A ravenous whale sweeps close.

It's a crisp, icy morning in Norway.
(Could it ever be otherwise?)

Workmen appear at the door.
You come to understand

 they await instruction.

 •

On the moon:

a ring of radiant slate

Mare Crisium,

 the Sea of Crises,

you thought might as well be

the Sea of Christ,
 that there might yet be

a miracle there, amid
mountains, plains, valleys,

spikes of light
around some rupture.

•

In the pool, the fish are orange and gold.

My hands still have the scent of the lavender I picked.

Bees dance above a birdbath.

The llamas lie down.

•

A process of condensation,
it has been argued,

brought the world to be.

Large chunks smash into larger
until there is a reality we might walk on.

•

The girls are floating
at the edge of the floating dock,
a diving raft close by.

 Bright cool morning,
but the surface of the lake is dark.

The girls are giving orders, naming items to be gathered.
They are bossy and beautiful, treading water.

Who could they be instructing?
Who else but the boy?

The beach is empty.

The boathouse is open, untended.

The girls are quite stern, but one of them likes him.

She has her arms out.
(The boy, it seems, is in the water with them.)

Her hands are on his shoulders,
in the swirl of the cold,

such warmth, warmth
flows down from her hands.

(The sky, the mountains, and the lake
flow into you through her touch.)

The boy and girl drift a bit farther out into the lake.

This is truly a wonderful camp, he thinks.

•

Air being light follows breath,

mounts till it reaches the fire,
away from earth and water

so that it seems to be

suspended from the fire,

earth and water

remain in their place,
mingled, kept in motion by
the breath of the word

which passes over them
within hearing.

•

The birth storm is coming.

Water and light will soon wheel
through the trees. The wind that would

bring the birth storm has already turned toward us.

Could I have heard the wind in my sleep?
Heard the first of the birth storm,

the herald that will lead us
wet, shivering with pleasure

into the elements,

just to breathe, just to see

the bark of the tree darken
in the horizontal rain?

AS WERE IT TO BE SEEN

ALONG THE LINES OF LAMANTIA

In bursts of sun
between racing clouds
the totality of the given assembles.
In a bar, spectral and dead,
a drunk is as distracting
as a bird that
cries out in spring.
In the yard,
sunlit whiplash:
a shoot bends back.
In the fissures of
the cave beneath
the temple, a
hallucinatory
mist rises from
the remains of a reef,
there from when Greece
was just water.
In a film, a bullfight
has interrupted
the motorcade in Dallas.
Not until the world evolves,
it seems, will the soul
be reborn. In the
mind, about which
much is still unknown,
Deadness and Denial are shoals
over which you drift,
respectful of what wrecks
they precipitate, but
called toward

the beyond.
In a market,
a woman appears
but her face is unstable,
and in a folktale a prince is
warned by a donkey
who speaks
about what will
happen at the feast.
Were all this
amassing in Fiji,
you would marry
a missionary,
traverse the world,
singing, for the glory of
Lord Krishna:
The world is fire.
Prayers are drops of water...
Still, in the night sky
the planets
are pulling away,
and in the morning
drained leaves radiate
amber and red.
In a dream,
the ghost of
Philip Lamantia
says: The time between
incarnations
is now
nothing.

PRETTY BLUE FLOWER

In 1969,
the daughter of the host of
House Party
plunged four floors.
That some truth might
arise from his grief,
the devastated
celebrity,
Art Linkletter,
on a special broadcast
of that once popular
variety hour,
showed a film
about the horrors
of LSD. A whacked-out
hippie girl looks at the flame
on a gas stove
and says:
"I want to pick
the pretty blue flower."
And she does,
she picks the pretty
blue flower
and, screaming,
burns her
hand half off.
And up in
Massachusetts a
boy home from
school with the flu

watches *House Party*,
and thinks: "Hey,
that's
interesting."

BACK

Chuang Tzu
asked the skull: What
do you want?
The skull
said: To be
rushing among
all those
who seem
still tumbling
from bed, to shower,
to street, to work,
hair still wet.
The river wind
must feel even fresher
for them,
a cold crown
to their
thoughts,
as they marvel
at the day's news
about minerals
found on meteorites…
I want to be,
the skull said,
back in
New York.

THE EXHIBIT

Not until
I see
you seeing
those glowing
squares, those
legendary
splendors,
see you
caught up,
lost in looking,
not until I see them
only in your
seeing
them,
will I ever
really see them,
really be
before them,
be in the truth of
those pulsing
colors, those
vibratory
gates
of shade.

CATHOLIC AUTOMATA

for Elizabeth King

From 1560, a statue, a six-inch monk: thin face, a sharp nose, Franciscan. His eyes open and close and look around. His face is long and bony, like an agony out of El Greco. The cheeks are hollowed. The paint has cracked. He has beaten his chest so much that a part of his chest has been replaced.

•

He raises beads to his lips. He kisses the cross. He wears a simple gray robe in honor of Saint Francis of Assisi, the founder of the order. The monk is an automata, made for a Spanish king. For as long as his spring unwinds, repentance rises to heaven from the earth.

•

In 1560, modernity was beginning, a shining future of secularism and mechanical feats. This particular marvel, this toy monk, was a gesture toward that once-nearing future, but also a throwback. He was an ingenious response to an ancient, impossible command: pray without ceasing.

•

The skull of the monk is full of wheels. X-rays of it look like modern art. They could pass for stills from the collage film by Harry Smith, *Heaven and Earth Magic*. The key to that film is a book by the doctor who found the part of the brain that hallucinates. He stuck a live wire there while a patient was still conscious. The doctor then wrote down what the patient said he saw.

•

The son of the king of Spain was gravely ill. The king begged God, spare the boy. The king told God: If my son does not die, I will repay your miracle with a man-made one. What if the king had called not for a monk, but a priest? What if it turned out their amazing toy doll could turn bread and wine into the body and blood of Christ?

•

Thomas Aquinas was once so startled to be spoken to by an automata that he smashed it to pieces.

•

And with a similar blow, Descartes broke the cosmos, and
automata, all those wheels and levers and springs, became
nothing more than illustrations of our own complex state of
being.

•

Vicente Carducho paints the saint flying upward, meeting,
midair, Christ on His pink-winged cross. The saint is joyous,
haloed and with hands upraised. He receives the seven
wounds.

•

*Praised be You, my Lord, for creating our sister Bodily Death,
from whose embrace no one living can escape.*

THE NEXT PLACE I VISIT WILL BE TIBET

As for slaves, gender, race, class, or age can never prove who
will be ideal. Ideal slaves will always be the ones who simply
step forward with open hearts.

•

Who already, deep in their souls, assent to this notion: even
though we are immortal, and have authority over all things,
we all serve fate.

•

A video of mine, "Merciless Beatings," offers an exceptional
slave. He told me he could take it, a real crucifixion, nails and
all. So, I gave it to him. He nearly passed out, but he was true
to his word. He could really take it.

•

I play guitar and flute. I burn CDs for my friends. I make
goddess gowns, speak other languages, and travel. I immerse
myself. When I garden, I design tiny fairy patches and secret
forests in the backyards of wherever I am a guest.

•

My first branding was too gentle. The second time, smoke curled. He sizzled. The scent sweetened the dungeon. He was from Texas. As he burned, I called him: My Longhorn!

•

A scream, like an evening play-party in Portland: inside the room, another room, made of clear plastic walls. Inside the room of plastic walls were three masters in masks, and a naked slave. The flogging was fantastic. Blood flew. I looked on in admiration.

•

At summer camp, the games would end with the girls chasing the boys to the finish line. I have kept that playful, creative spirit. As a Sadean, I accept the power of any tableau, spectacle, psychodrama, play, any mind-fuck with multidimensional levels.

•

I have a pretty voice that burns into the brains of my slaves. Often, I give commands in Czech, which no one seems to understand. As I recently pointed out, also in Czech: "This is not a democracy."

•

I cuff a slave to a park bench and put the key in his boot.

About thirty feet away, I wait, blowing smoke. If an attractive woman walks by, I sent a jolt through the electric ball shocker.

•

I call myself *Madame Absolut*. When less philosophical, I can be a very bad girl. I love fist fucking, for example. One minute, my touch is as light as a feather. The next, I'll pull your insides out.

•

I was raised Catholic, I knew nothing. Our au pair, Sadie, straddled him. (I had never seen a cock before.) He, a close-cropped Marine, convulsed. She leaned. I always love, she said, that look on a man's face.

•

My dungeon: "Justice."

•

I want to see the world, and learn about myself. The next
place I visit will be Tibet. I want to find a quiet corner and
pray with the monks.

•

The more cruel I am, the more compassion I feel. His head
in my lap, I tended his wounds. The two of us formed a bond
that day that touches my heart even now.

SNAKE ISLAND

As fate
led Magellan
to miss every last
island from South America
to Guam, so we move
through these
equatorial fires
and flying ocean snakes...
Today has its color, a piercing
gold-orange adornment
hung on the altar of the sun.
. As we arrived, the voyage
took a darker turn.
We were not to say
the word *terrorism,*
though three Lebanese boys
just got their throats cut.
We slipped on robes, said
we were more or less Muslim.
Then the one called
l'ancien guide
snuck us into Algiers
where, through the thicket of
branches before dawn, a face
looked down at us from the sky.
What in the film seemed
silly had acquired real terror.
We felt caught and demolished,
and we dreaded the day.
It reminded me of Prague,

which reminded me of
Tangier, where a flatworm
ran amok in my guts.
Chill and dull at 3,
drenched and alert at 5.
The fever keeps me
restless. We step off
in a land where plants
die out. People leave.
Creek beds fill with dirt.
From somewhere, you say
the glittering will fill the roads.
A deeper silence will reign.
Only then will I respond
the tree blooms in violet petals.
Or: a current of air touches
and turns away at my face.
Or: I have hidden in a body
that is not my own.
Chill and dull at 7,
drenched and alert at 9.
Laws that order the world
seem now to be changing.
New York. A subway ghost
points to a sign on an
incoming train. Look
at that word "to,"
he said. There are two
ways to read that word "to."
Everyone must choose, he

said, George Oppen said,
which they can best believe...
Then the night rose up
like a blackboard
with a syllogism
written in starlight.
But there can never be
an equivalence between
A and *C,* we responded,
because the world
we are now passing
through, the world of *B,*
is all hatred and lies...
But one new truth
gives way to another.
We crawled out
onto Snake Island:
There are further
trials the snake god has
arranged for you,
King Skelo said.
In one, a bird will
burst from a gold orb
that you hold in your teeth.

TODAY

Half in the truth,
half in a dreaming shell...
The scent of champagne
lingers on the deck of the wreck.
So what does it mean that
a blind woman drops
an egg in a frying pan
and mentions Plato
or that, at the paint store,
a man says: I would like to die
in an incandescent house
where a tooth in the hand
of a sleeper is a spider
crawling into a bandage
of a wounded composer,
an ascetic recluse.
Bed, piano, a crucifix
in a small Spanish room.
(Though his music is
praised for its sensuality.)
Years later, on a beach,
you may yet see the blaze
of pebbles in a primordial swirl
around the larger stones.
But for now, not far from here,
the sky is still the color of ice
and kisses stir hysteria,
despite the fact that
the ocean floor
is a volcanic simmer

where microbes
devour poisons and,
amid eruptions of methane,
gush pure oxygen.
Today is simply
dark and humid.
The sins of the earth
are sticking to your skin.

ALREADY ROMANIA

for Julian Semilian

A horse-headed god
with four wings in a wind.
How else did we awake in a forest?
As if this were already Romania,
a restaurant where we await
a dish a king once tasted
and died from delight.
Or just the table of silence
where Brancusi looks
eastward across the steppe,
like an invisible apostle waiting
to be shot through with light...
A beautiful girl on the corner
in a black T-shirt calls out
for the execution
of a political journalist.
A raindrop bends a leaf.
In the next town, the police
are mean. We were lucky
to be nabbed here and now.
And in this garden, in a glass
bubble, one can read for hours.
And the delighted demeanor
of the children, will they
become prison guards,
or their guests? Close in,
future. The leaf dips, blessing
the storm. Trees push the sky back.
It is too late for lightning.

Too late for a path
to the legendary east
where a wise man,
Agastya, is floating
cross-legged in twilight,
and the hills glow green.
It is too late for a trial,
but not for a simple test.
First, find a crowd.
In that crowd, find
the most unhappy face.
Then, find the most
enigmatic face.
Then, find the one
face ready to be reborn.

AS WERE IT TO BE SEEN

I did not relish returning to
that garage guarded by a flock
of predatory geese, but I was
in love, never happier, though
in my psychic portrait my
face is split five ways. The artist
calls me "a colloquy of demons."
On the sun, holes tear open. Blackness
inside the burning. My new calling
is metal weather vanes, the birds
all done in copper: hawks,
herons, my ibis will crest
the cupolas across these hills.
I feel like I live in a forest of flame
with my mind always elsewhere.
The pomegranate leaves are yellow.
Fruits go gold in the cold snap,
some burst: a flash of a gash
in the air, a ruby-colored
wound, which, like my face,
is no more than a momentary
flare. My thoughts blow clear,
like air at the Arctic. Forty years later
the tree turns crimson on the hill.
The grass fades to blond.
In every profession and caste
benevolence has gone berserk.
We were becoming fantastic, with
many heads, dozens of hands,
each wall a slice of light.

In the midst of a meditation
our material bodies dissolved.
A perky thirteen-year-old
walks in, asking for sex,
and the entire palace fades,
and is, again, a laundry room.
A lifetime of flowing shadows
is the sum of what is known.

HARDLY HERE

The world itself is
dissolving within
a luminescence called
The Maw of the Dragon.
Still, the handyman today
is chatty and distracted.
He hangs a mirror.
This job will let him,
he says, accompany
a casket back into the
hinterlands, even as
the dew freezes
and the ground is
breaking like grass
beneath our feet. The
phone poles all have
a shining white stripe.

•

Or else the sun is falling
through the floor of
the earth. And while
(as we have long felt)
consciousness is
a continual fire,
in thinking about it,
we're hardly here:
we're shadows

dispersed in the
freshly washed air,
corporeal enough only
for one last contemplation
of light and dark, at
twilight, at a ski resort,
as a chairlift arrives
and you step down,
overhearing the
One Truth:

•

My daughter had bleeding.
We decided to drive.
Then we could be in touch
on the cell as
she was rushed
into the ER.
Halfway through
Pennsylvania,
we heard: the
bleeding
had stopped.
She was ecstatic:
they still had a heartbeat.

NIGHT FLIGHT TO PORTUGAL

Is this the
pit of the spirit
or only
 an Alhambra,
in Lisbon, by the sea?

The waves are
slabs of Brazilian
marble

 and the seaweed
a dust-colored
swirl beneath
the spill of
green.

A rich white,
tinged
with rose,
seems to be
flowering into
the table
 where
I write:

 "Just beyond
the door, the
ocean.

It was night.
A friend
was leaving."

LOS ALAMOS

The great loves
of Los Alamos are
 declassified,

the frenzy before
the test, the pulse
in scientists
and wives
alike,

wild parties
in the desert,
decades ago,

where, on dark
mornings
much like this one,
chat meandered
from rain to rituals
in the *Rig-Veda*

to a sci-fi species
that, wounded,
oozes an irresistible
intoxicant. Our
intergalactic
harvesters
cruelly wring
the blissful drops
from their far-off

and harrowed
alien flesh.

Enchantment
pushes on, deep
into sleep, with
dreams more
extraordinary
than any
entering
your head,
where of late
you live and
grieve, as bereft
as Gilgamesh, his
love lost in
the monstrous
realm of shades.

The sun comes out.

The rain comes back.

It's a mystery
much like those
hinted at in
an old lullaby:
I wanna get high,
get high, get high,

*then I wanna lie
down, lie down,
lie down and die.*

Though this early
on, a sip of
champagne
is recommended.
It gives the enwombed
a taste of the pleasure to come
even though the
earth shivers with
pain and the village
we hail from
has been eaten.
The once efficient
kinship system
is so crosshatched
and spliced
the ancestral
dead are
bewildered.

And the spirits
adrift in our
daily lives have
no idea who we are,
or what they can
do to help us.

THE BUCKET

Let this all
again be
North Africa in
the Middle Ages.

A beautiful woman
in a spellbinding
gown walks
through town
barefoot, a torch in one
hand, a bucket
in the other,
crying out:

"I have
come to
drown hell,
and set fire
to heaven."

NOT THE AFTERGLOW

The birds have dipped too low.
Now they are trapped in Purgatory
until they understand the song
pouring from the mouths of frogs.
Otherwise awake, you feel you have been,
though the incident barely trembles
at the edge of thought, abused,
defiled, raped, debased, and
shamed. There is no recourse
to a counselor about this, no
procedure of grievance, nothing
to say but that a conversation
happened. It appeared lighthearted,
and was what, in other contexts,
would be lauded as "productive."
Yet later you feel somehow
you are bleeding, that you
have been beaten and pierced.
A sudden wind brings sounds
of innocence, then pushes the boat
back to sea. This is not the afterglow
of satiety; you sleep deep in the hold,
on a voyage that will chart the
distance from the dell of heaven.
In the darkness, torch tips of foam
flicker atop the turning water.

DISTANCE

A bird pipes up, which might have
alerted you to your newfound
higher nature, but then
a couple appears
at the door bearing
fresh mint for
mojitos. You had,
you thought,
outthought your
instinct for error, but now
you see the brilliance
of those old plays
where all that
befalls is known
in advance. The lover
first sees the fated other,
first exclaims, first
stands dazzled,
splashing in aqua
shallows on
a honeymoon
in Turkey, though
at this distance
the red numbers on the
digital clock
look more like
a forest that is
burning.

PLURAL BLUR

Then, as if your beauty
were not the secret reason
for the gathering, you
appeared. No receptionist
followed fast, no one
required to intro-
duce us, so at least for a moment
we could feign that the cycle
of death and rebirth
had cleansed us
of memory, that we
had never met before,
had in no previous life
so spectacularly and
destructively
loved each other.
And as these dreams are
so indebted to Dante
none should be surprised
to learn I woke up on a slope,
light falling far through the cold,
my face and arms reporting
a sustaining warmth.
Then, on the barest of
branches, a red blossom.
And so I understood that
the immense cycle of
migration that the birds
are in the middle of
is not essentially

different from our own,
except a bird lives the flight
of its thoughts over an
earth waiting to explode.
The green hiding deep
in the dry tangles is
as impatient as the grave,
or the stroke of the pen
in a drawing called
Plural Blur. It seems
the lines are pouring downward
but they are angling up,
the black shadowing
the blue against
a dingy white sky that
seems to have been brushed
with the color of a blush
of a thought, of a
thought of the light
of a far more
passionate galaxy.

after a painting
by Eve Aschheim

KASHMIR

for Donna de la Perrière

It is not yet evident
where the mountains will
loom when the mist fades, that
wall of white behind the
horizon where the lake
should be, assuming
night was not as drastic
as it felt when it
took away so much,
when it seemed nothing
would continue once
the dark concluded, like a
devastating message
amid a carefree
moment and for
the rest of the day,
part of the sun is buried,
hidden for safekeeping,
but who made the request is
unclear, perhaps a bird,
or, in a forest at night,
a deer that held a
constellation in its crown,
a deer that looked at you
once, then vanished.
But what is ever to be
believed? The planet turns
and at least while asleep
we are on it, wandering.

Then she's right there,
talking to you, as if you
were about to resume
your life together.
She looks happy and
young, as if the furors of
the intervening years
are the dream. Was this
the love for which one
presumably waits?
Was this, at last, the rare
occurrence, in its proper
place and time, in a dream?
She is telling the super what
needs repair before the
wedding day. Her voice,
her waving arms, fill the air
with life, the new life,
set to begin once
the night climbs
into the streaks cast
before it over the ridge
behind the lake, and
the nuance of receding day
is lost in what else
but an intensive,
six week Spanish class.
Pretty soon you can't
help it, questions
leap to your lips in a

language unknown
until now. What is the
weather like? What is the one
myth that exists for you, that
locates your life beneath
a blue-black sky
shot through with rose?
Coming over the hill
it's hard to watch the road.
The bay sparkles. On the radio,
Led Zeppelin: "Kashmir."
I was thinking: I can't
believe I get to see this,
live here, be alive, here.
Then I smash into a guy
who stops short.
Have you ever been
hit by an airbag?
A powdery chemical
fills the front seat. It looks like
smoke, but isn't. The
wisdom is, stay put.
But the first time you
total a car, you're frantic.
You want to get out: you
think you're on fire.

EQUALLY PROBABLE

Our astonishment was
greater for our knowing
that these two events,
the multiple suns
at earth's edge and
what rushed in our blood,
were unrelated. A net of
gentle bright threads
shimmered around us
till night fell and we
came down from the roof
and put on some music.
An adjacent reality
was revealing itself
whenever I was with Lisa,
even when she said go away,
I don't want to see you.
The suns broke apart
and dropped into dreams
that came to me tucked
in a dry niche under
a highway overpass
while thumbing my way
to an intertribal caucus
where I met the man who
took over Alcatraz.
Later, back east, with
no great precision
I cut a wrist open in

a ravine where
the Great Awakening
tore time in half. It seemed
rebirth no longer
presented itself
under the strictures
of "lived experience."
Flashes of our future
were arriving as
what we recalled of
who we were; whole
chunks of upcoming
incarnations hid
in the crease of
the now, seeming to be
no more than what
happened to us long ago
in Greece, Rome, or Atlantis.

THE TRANSMIGRATION OF BRIAN JONES

I think me 'ead's on fire.

<div align="right">—BRIAN JONES</div>

I

A dog trots in,
a crust of blood
around its neck, and
suddenly the symposium
on melting glaciers
and emerging
economies stops.
All are only curious
as to what the dog saw
and felt, first as a headless body,
then as a bodiless head
in its long meander
here to the tip of
Tierra Del Fuego,
though this may be
the Cape of Good Hope,
this dilapidated
hovel where in back,
in a thicket in a ravine,
a man lies shoeless,
unshaven, skeletal,
but for all that, upbeat,
saying: "The only
way out is a ghost of a road
through the slime fields
to our once glorious
capital. When you
hit water, catch a

boat to London.
The Rolling Stones
are waiting for you..."
(So, is this who you
are, your death just now
proclaimed, in the
waking world,
murder? You are
Brian Jones?)
"Once back in life
remember: the
instruments are not
the same. Chords are
otherwise: some
no longer exist, while
others, once
only imagined,
have come to be.
The blues are obsolete.
Worldly suffering
is over, save for
in the mountains of
Iceland, where people
gasp at the threshold of
what can be borne.
As for yourself,
try not to despair.
Here in the beyond
those tapes you made of
The Master Musicians

of Joujouka have
won you
a degree of
favor."

II

Trammeled ocher chunks of
hay and enchantment dust
over battlefield gore.
Red wash, smoky mud.
For a moment this is
Uruguay or the Balkans.
All that can be sure is
the ocean is straight ahead.
If only, you think, you
had been swept to heaven.
If only you had not been,
if only you were not still,
a wastrel dilettante addict
facedown in a pool and
dreaming of nightfall
over a canyon river,
smooth white rocky banks,
a boat tipped on its side,
flipped over, propped up,
the night wide over the desert.
Out of nowhere, a rushing,
a storm, a microburst,
half a planet's worth of
inundation. The sky opens,
the ground simmers.
The green of the water
has a feathery streak of red.
The desert soaks up
none of what falls. It all
dumps into the canyon,

a thousand waterfalls,
all around, braids of water,
upside-down trees of water,
dangling rope ladders
of water; all that sound,
you, at the center of it.
You are all sound
in its coming and going.
The waterfalls swell the
river. The river turns red.
It's a monumental
catastrophe, flat-out
biblical, some old battle
or footage from Africa,
slaughter escalating
from bullet to blade.
Though all seems cleansed,
clear and shimmering.
The river drops back
and is green again.
Day brings word of
searing heat, hailstones
and intermittent whirlwinds.
But anything beats this
room, dark and empty,
where nothing is
gained by waiting.

III

The two of you start walking
toward the mountains
of California, or Nevada,
farther than ever from
London, where you were,
once, the master of
the guitar, the sitar, the
harpsichord, the marimba.
Ruins loom, a Greek Orthodox
church where he has been
living, the boy says,
since his father died.
He picks up a trash bag
left in one of the pews,
digs in, and pulls out
an extraordinary yo-yo,
black and violet depth
and flecks of glitter in
degrees of density.
As it spins it seems like
a model of a galaxy
that had broken off,
drifted away, was now
apart from the darkness
of space, and that one
could see the stars
as they appeared
within a dark and
inexplicable whirling.
Next, a ticket stub

from a dry cleaner's
that no longer exists.
"This was our world,"
he says. "Weekends
we slaved here
sorting the hangers.
This was our big chance.
It almost ruined us.
A mysterious fire
turned it all to ash.
My father thanked God,
never getting he should
thank instead Uncle Nicky
and his years in the Army
where he learned
all about explosives."
The boy wandered
off and you awoke,
the astonishment of
morning light coming
in over the wrecked altar,
washing the mosaic.
The whole church shone
gold, brown, red, blue,
bewildering and beautiful
scenes rendered chip by chip,
the chips a continuous
ripple of light. Then
Jesus could be discerned,
by the sea, calling his

apostles, or floating
on the mountain,
in waves of light,
or taken down from
the cross. Elsewhere
your old intercessor,
Doubting Thomas,
dipped his finger
in a stream of blood
that seemed the essence
of the glimmering gold air,
as if the color itself were
a thread hidden in the
weave of the dream,
and, now that
you had noticed it,
would disappear forever.
(As if a meaning could
never be complete
until its existence
were forgotten, until
the earth held no
last trace of it.)

IV
A moment ago the horizon
was level, was a slash
across a canvas with a knife
to illustrate the
descent of a star.
Now it's just dangling
fabric, drenched in gunk.
Was a hotel, where a machine
would show the truth in
the heart of whoever
drops in a coin, but
a woman behind the
counter says: That
machine is broken.
Then the dreams turn
deeper, become even more
recessive, like shelved
bones in a catacomb
seen by candlelight
where Love took you
on your first date,
a girl in a chiffon frock
leading you through
the hollows full of martyrs
emerging along a lake,
which becomes a cloud
that has fallen into a ravine
in a city invaded several
times a lifetime, so that
even the street sweepers

speak four languages.
Each had been asked in
his native tongue
to execute his neighbor.
(Bones jump up from the
mud after a strong rain.)
This footbridge over the
abyss has just become
a rope trailing a boat.
Though a swift current
carries you, you are still not
pure enough to hear
what the rustling of
the water really means.
But there is progress.
What you hear is
a new kind of thought,
known for now as music.
(You are still a musician.
Death does not change that!)
A woman has put her hand
on your shoulder, and says:
I have just dyed my hair
red, and will help you.
Your chart shows
Saturn and Uranus
at odds ever since the
moment of your murder.
This will intensify until
blood and semen fall

into the first sea and
magic happens.
Lie low for the night,
perhaps in a warehouse
filled with strips of white
hanging from the ceiling.
In the apparently empty dark
shadows shine through
each waft of cloth,
take familiar forms.
One may speak,
a sister, missing
since birth, who now
gathers nettles and
raspberry leaves
to make you a broth.

V
But for now, only the
mountain mattered. The
poet pointed to the first low
ridge, the boulders there
giving off a blue-gray
glow in the twilight closing
over the desert that,
were you to turn back,
might still be there.
He showed no sign of
the illness he had recently
written about with an exact
and strange power. This
gentle yet adventurous
man known to you
in the waking world,
why was he the one to
show up the night of
your birthday, in a dream,
to point to a mountain
and lead you to it?
Perhaps because only
in his presence would
come to you this sudden
strength, the proof
is your quickness
following him up that
first ridge to look across
a vast, angular plain of
black stone with the blue

under-lighting you associate
with coal that is burning.
"Only one material," he
said, Ed Roberson said,
"can survive the death of
the earth, and that would be
diamonds. So, look around.
Scavenge enough glitter
to write a text for eternity.
And whatever would be said,
and how, since no human
will be alive to read it,
whatever truth we want
to send to whatever life
evolves on the moon of
Saturn that scientists say
will turn earthlike as
the sun goes nova
its final billion years,
should these your so distant
correspondents have the
leisure to puzzle over,
in the wreck of a
fossilized space probe,
speckled stones scratched
with microscript, try to
reveal, in the last gleam
you give your words,
flickers of a love that
once brought new
worlds to be."

VI

Otherwise your job is
to hold the bowl that catches
blood flowing from a single
steely swipe, and when
mornings are as cold
as they can be, here
in the mountains of Peru,
the steam off the pulsing
blood will be the only
warmth there is.
It's a cloud, now,
that carries you out
across the ocean. So,
much like the goat, you're
aloft in the glory of a no less
sacrificial, if purely psychic, violence,
adrift in disembodiment.
But in the end, the goat will be
welcomed into the world of
the forces that have
led it to its fate.
Yes, when the ecstasy
of death concludes,
the goat will join with
what has long been
understood to be
a "universal
consciousness"
from which, by
contrast, and for so
long, you have felt

painfully, shamefully,
excluded. To your
credit, you say nothing.
Mention of it, you've
found, proves
disruptive. People
feel you blame them.
They create a second you.
(You watch them do it. Aghast.)
They say that this is
what you really are,
and all the good you've
done is discredited, is
forgotten, means nothing.
They validate their moral sense
by making you grotesque.
They replace you with
this other you, who lives
only to be shunned.
In the end, basic civility,
even a greeting on the
street, is denied you.
They see you coming
and turn to look at an ad
on a passing bus, or the faces
of lost children, or dogs,
plastered on a lamp-
post or on the
plywood nailed
over the window of
a bankrupt business.

VII
It seems Colorado
has a new train station
and dazzling, snowcapped
peaks on the horizon.
Could you be entering
the famous mile-high city,
Denver? Or is this a less
known outpost, higher up,
some new and secret
Machu Picchu? Seems
it should be morning
but evening drops. Your
companion has vanished,
the mysterious woman
in a black dress with
whom you were walking
down an empty road, holding hands,
just as a small welcoming party
spilled out into a driveway
from a brightly lit-up house,
the sky vast and dark
and full of stars, like nothing
ever seen back east. The
blue-black of infinity itself
seems to glow, as if lit
by a cosmic surge
on the sky's other side.
This must be, you think,
a life never known until now,
the life of life in Colorado.

High up, overhead,
black specks are moving fast.
Their thin streams grow
dense. Just another aspect of
the Colorado night sky.
Visitors get spooked,
but locals take no notice.
The broadening blackness
hides some of the stars.
Other, thinner streams
flow in from all compass points.
Straight above you dark grains
are bubbling, like a spring
in a forest in a legend,
as the tributaries meet.
A few stray grains brush
against your upturned face.
Celestial grit pings and ticks cars
and mailboxes along the
streets, high in the mountains
of Colorado, where your
new life, the life of love
as lived in Colorado,
is beginning, though
you find yourself alone
in a driveway at night.
The sky pulses and twists with
carbon-colored sand.
A cascading blackness
fills the darkness of night

now spilling downward,
as if this world were a
bulwark about to be
breached. In the house,
the party rolls on.
Do they well know what
this phenomenon is?
Would they find your
concern endearing, as if,
drenched in seawater, and
a dog, you had rolled around
on a beach of black sand
arriving from the sky
in magnetized streams?
Then you see these
massive sheets of light,
squares of luminous metal,
two of them, in quick order,
with several small bluish-green
rings (and a sequence of dark
parallel slashes that look
like vents) cutting through
the black flow of the sky,
the flood of carbon filling
heaven the night of your
arrival, in Colorado.

Joseph Donahue is the author of five full-length collections of poetry, including *Incidental Eclipse*, *Terra Lucida*, and *Dissolves*. With Ed Foster and Leonard Schwartz he edited the anthology *Primary Trouble: An Anthology of Contemporary American Poetry*. With Ed Foster, he edited *The World in Time and Space: Towards a History of Innovative Poetry in Our Time*. He has lived in New York City and Seattle, where he was a member of the Subtext Collective. He now lives in Durham, North Carolina, and teaches at Duke University.

Red Flash on a Black Field is composed in Interstate and Copperplate types. The display faces, Nueland and Blackoak, appear on the title page and cover. One thousand copies of this book were printed and bound at Thomson-Shore printers in Dexter, Michigan.